Capturing Time & Motion

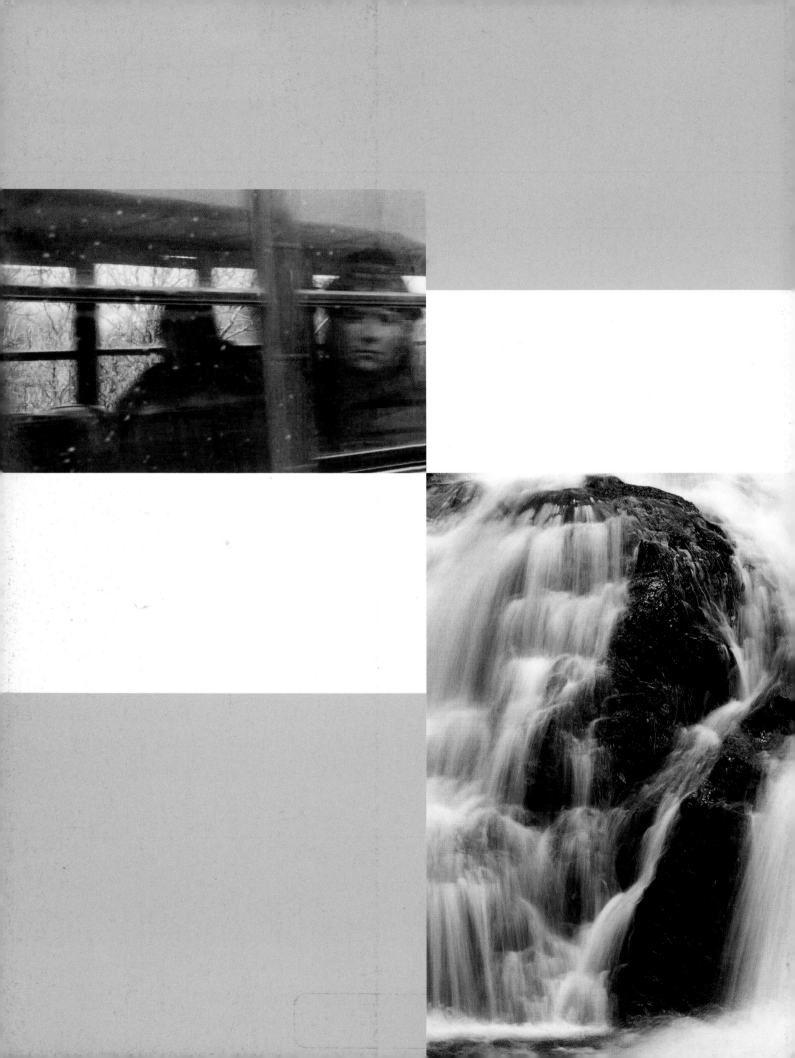

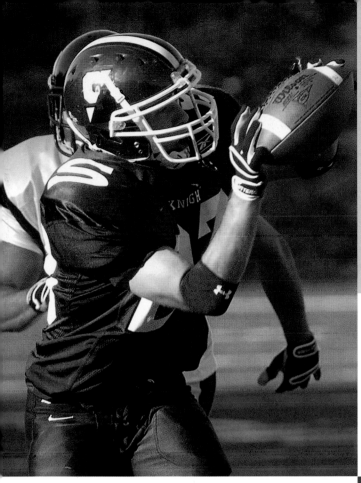

Capturing Time & Motion
The Dynamic Language of Digital Photography

Joseph Meehan

LARK BOOKS

A Division of Sterling Publishing Co., Inc.
New York / London

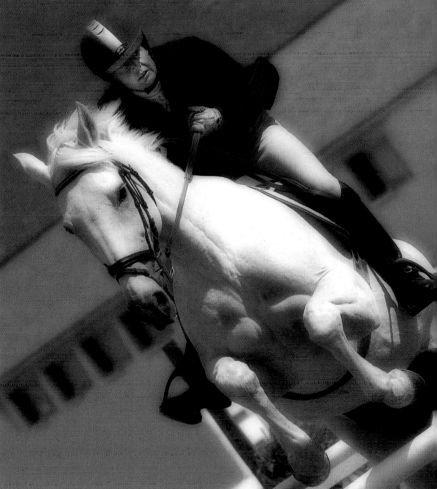

Art Director: Tom Metcalf
Cover Designer: Thom Gaines
Production Coordinator: Lance Wille

Library of Congress Cataloging-in-Publication Data

Meehan, Joseph.
 Capturing time & motion : the dynamic language of digital photography /
Joseph Meehan. — 1st ed.
 p. cm.
 Includes index.
 ISBN 978-1-60059-467-0 (pb with flaps : alk. paper)
 1. Photography—Digital techniques. 2. Image processing—Digital
techniques. 3. Digital cameras. I. Title.
 TR267.M42 2009
 775—dc22

 2009003797

10 9 8 7 6 5 4 3 2 1
First Edition

Published by Lark Books, A Division of
Sterling Publishing Co., Inc.
387 Park Avenue South, New York, N.Y. 10016

Distributed in Canada by Sterling Publishing,
c/o Canadian Manda Group, 165 Dufferin Street
Toronto, Ontario, Canada M6K 3H6

Distributed in the United Kingdom by GMC Distribution Services,
Castle Place, 166 High Street, Lewes, East Sussex, England BN7 1XU

Distributed in Australia by Capricorn Link (Australia) Pty Ltd.,
P.O. Box 704, Windsor, NSW 2756 Australia

If you have questions or comments about this book, please contact:
Lark Books
67 Broadway
Asheville, NC 28801
(828) 253-0467

Manufactured in China

ISBN 13: 978-1-60059-467-0

For information about custom editions, special sales, premium and corporate purchases, please contact Sterling Special Sales
Department at 800-805-5489 or specialsales@sterlingpub.com.

Dedication

The career of every photographer is enriched through associations with many fellow professionals. These are four colleagues whom I would like to acknowledge for their generous help and support over many years.

David Maffucci, Fatima NeJame, Harry Ricketts, and Marti Saltzman

 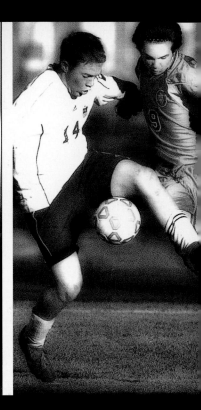

contents

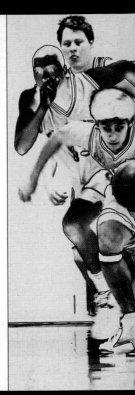

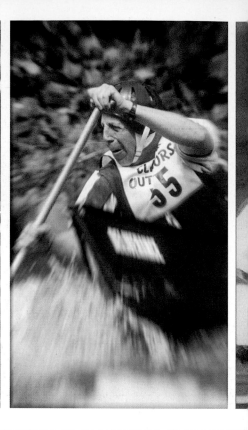

1

The Language of Time and Motion

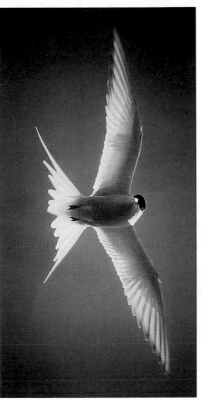

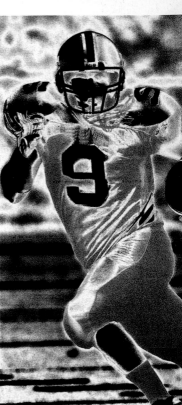

A photograph is a representation of the three-dimensional world (height, width, and depth) compressed into a two-dimensional medium (height and width). In an attempt to expand this limited medium, photographers often use illusions produced by different types of lighting, clever compositional devices, or various props to add an appearance of depth. In addition, there are also methods that allow you to introduce the aspects of movement and time to photographs. By drawing on visual representations of motion in a scene, as well as including clues to indicate the passage of time, you can produce a photo with an impact that goes beyond its height and width. Representing these added elements in a photograph is what this book is all about.

There is certainly nothing new about capturing motion or creating a sense of time in a picture. Sport photographers constantly shoot fast action situations, while landscape and nature photographers record the movement of water, the effects of wind, or the motion of animals. There are a number of "motion techniques," like using a slow shutter speed to blur rushing water, or a fast shutter speed to freeze the speedy movements of an athlete, and there is a

Capturing the Illusion of Motion and the Dimension of Time

distinct photographic language used to visually communicate motion and the passage of time in a photograph that is important to recognize. These techniques range from subtle to extreme and allow plenty of opportunities for creativity. Identifying these qualities and understanding how to use them can greatly expand any photographer's range of artistic expression. To communicate these techniques requires an appreciation of both the aesthetic and the technical aspects of motion and time and how they are represented in a still photograph.

While it is certainly valuable to understand the technical aspects, the key to successfully translating time and motion in a photo is to recognize the appropriate opportunity for applying this language. It is crucial to develop a sense of how motion and time can be captured to varying degrees in various situations. To this end, a number of visual illustrations, from expert photographers in the commercial and fine art worlds as well as from myself, will serve as examples. This diverse sampling of styles and techniques will help you gain an appreciation of the range and power of this unique language of visual expression.

When a photographer prepares to take a picture, one of the first considerations is whether the subject is static or moving. This can include the general movements of the whole subject, parts of that subject, or other separate features in a scene. These different aspects of motion, for example, might be represented by a runner traveling past the camera, a seated person making hand gestures, or water moving in a forest stream on a windy day. With this detection of movement also comes a sense of time: Are the events happening slowly or quickly? Is that runner jogging or sprinting? Is the person making casual movements or frantically waving his or her hands? Is the stream moving slowly or rushing by rapidly, and how fast or slow is the wind moving the trees of the forest? Speed is certainly a basic component of motion and is closely associated with the sense of how much time has passed. Speed will also influence the technical choices for producing the desired impressions of the events taking place. The primary questions you should always ask are: What role do these qualities of motion play in my photograph, and how will they add to the picture?

Composition

It is probably safe to say that photographers are most often concerned with movement in a scene because of the general desire to render everything in sharp focus. The reason for this is obvious: The viewer can see a subject's physical characteristics in detail when it is clearly recorded. Individual physical qualities—such as shape, texture, and contour—combine to define a subject, and recording them so that they appear sharp requires accurate focusing. It also requires a shutter speed fast enough to prevent any blurring that can occur from movement in the scene or from handholding the camera.

To portray movement in our photographs, we will enter a world of expression in which shutter speed plays a more diverse role. Therefore motion is something that we are going to use rather than try to eliminate. Let's consider a general overview of the ways in which a photographer can combine opportunity and creative thinking with certain technical controls to exploit the visual impressions of motion and time. I will then expand on each of these topics with more examples in the following chapters.

An effective composition is, of course, critical to any successful photograph. When dealing with the added visual qualities of motion and time, however, the photographer has to be sure that traditional compositional devices will support these qualities. In fact, it will often benefit the motion photographer to "bend" the rules of traditional composition. This begins with the most basic of all decisions: How to frame the scene in-camera. Framing the picture can be challenging. You must not only organize the visual elements for an effective presentation, but you have to do so quickly while working with a changing situation. Later, while processing photos in your computer, the decision to crop (or not) represents the last chance to refine what will be seen in the picture.

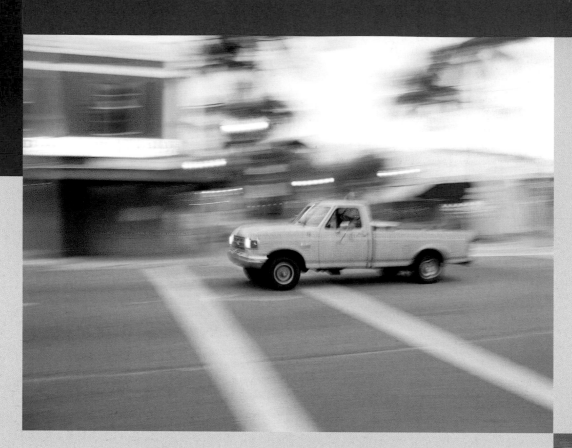

Consider the set of images showing a photo of a truck cropped three different ways. The first frame, above, is the original photo produced by a panning motion following the truck with the camera set at a shutter speed of 1/15 second. One of the primary characteristics of motion photography is a sense of

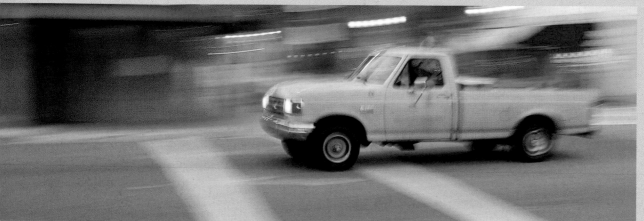

direction that can often be preserved or enhanced by cropping the image. The crop illustrated directly below closes in on the main subject for a tight composition. That's fine if the "raison d'etre" for the photo is to record the truck, but the lower frame (opposite left) has made provisions for the direction of the truck's movement, clearly supporting a forward path of motion.

So, while the tightly cropped frame (above) gives more importance to the truck, it detracts from the sense of motion illustrated by the longer horizontal crop to the left. The next chapter reviews the points of composition that have the greatest influence on portraying motion and time, and explores some of the more non-traditional arrangements that can be used.

Focal Length, Aperture Selection, and Perspective

As you organize what will go into a photograph, the ability to refine the composition can be affected not only by the position of the camera, but also by the selection of a specific lens focal length and aperture. These factors, in turn, will have an impact on the way motion and time are represented beyond the basic compositional arrangements. Focal length controls the spatial appearances between the subject, foreground, and background. Thus, with telephoto lenses, a sense of compression occurs, pulling together the subject, foreground, and background into what appears to be a closer spatial relationship. By contrast, a spreading out, or decompressing, of these relationships occurs with wide-angle lenses. In addition, wide-angle lenses will enlarge subjects proportionally. That is, the closer the subject is to the camera, the larger it appears.

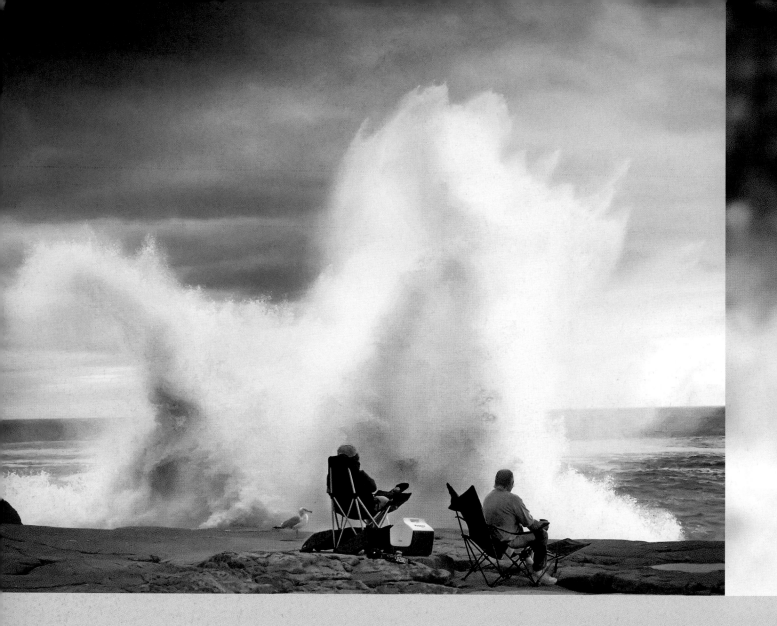

The dramatic compressive effect of a 300mm telephoto can be seen in the example above, where two people seated at a beach look as though they are about to be engulfed by a wave. Actually, they are about 50 feet from the water; if you look closely you can notice an unconcerned seagull between the woman and the wave. In the next example, the kayak competitor and the swirl of water also seem to be in very close proximity because a 400mm lens was used. In reality, the swirl of water is about two feet in front of the paddle shaft.

Aperture selection will further refine spatial relationships by controlling depth of field, which is defined as the area in front of and behind the point of focus that is acceptably sharp. A shallow depth of field can be used to isolate a sharply-focused subject against an out-of-focus background. Large depth-of-field areas, on the other hand, will have an integrating effect by keeping everything in sharp focus.

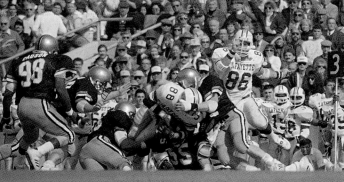

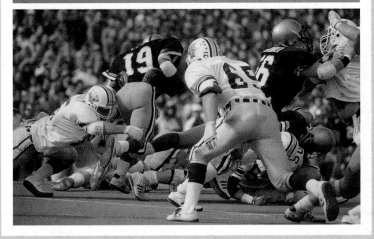

The different effects of depth of field with telephoto compression can be seen in the example at right. The upper photograph shot with a 300mm telephoto set at f/11, brings the spectators into enough focus so that they almost merge with the players on the field. Conversely, in the bottom photo, a setting of f/4.0 better isolated the players from the spectators. Notice also how a low camera perspective in both pictures gives a subtle feeling that the viewer is actually on the field and in the game.

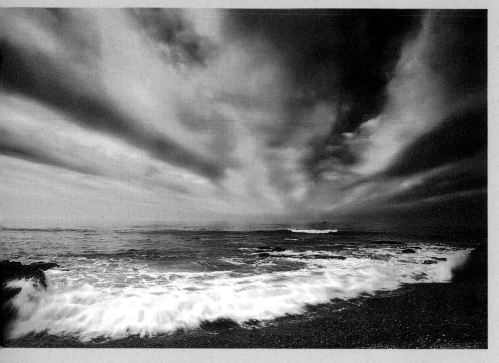

Another perspective that can produce fascinating results occurs when a photo is taken from a moving point of view such as a car or a train, as demonstrated in the dynamic self-portrait by photographer Diane Franklin (below). Positioned so that her reflection appeared in the passenger-side mirror, she was in a car moving at about 25 mph with the shutter speed set at 1/4 second.

In the example above, the use of a 24mm wide-angle lens set at a low perspective spreads out the spacing between background and foreground while enlarging the portion of the waves closest to the camera. The lens also causes the clouds to spread out in a fan-like rendering, while a relatively slow shutter speed of 1/30 second is just enough to give a hint of blur motion to the front of the waves. The impact of focal length, depth of field, and camera perspective are clearly evident.

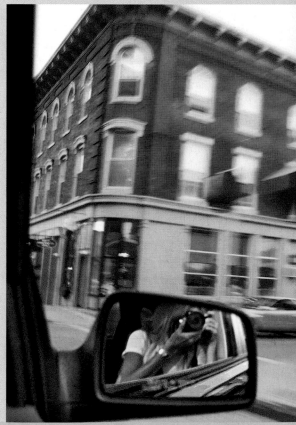

© Diane Franklin

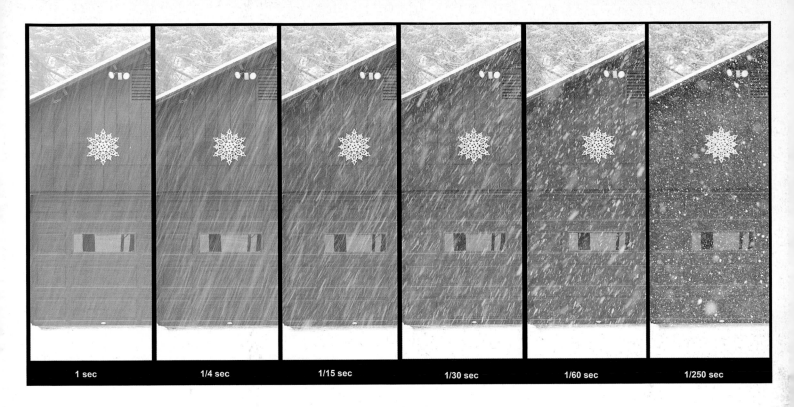

| 1 sec | 1/4 sec | 1/15 sec | 1/30 sec | 1/60 sec | 1/250 sec |

Shutter Speed Effects

Producing the illusions of motion and passage of time in a still photograph through the use of different shutter speeds is a tried and true technique. That is, you can use a fast shutter speed to freeze very fast movements, or a slow shutter speed to blur movements, as seen in the examples above showing falling snow. Clearly, it is the differences in shutter speed that control the way the snow will appear as blurred streaks or as separately defined flakes of snow. Thus, you have the option to stop the snow

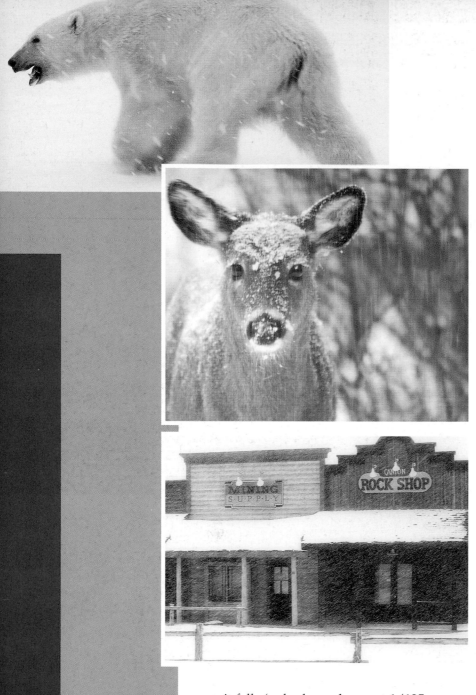

windless day. These examples show that the way in which motion is recorded can have effects both obvious and subtle. The first step is realizing that such visual elements exist, then understanding the impact of how they may be recorded.

The use of a fast shutter speed in a scene can often produce remarkable effects. When using such speeds as 1/500 or 1/1000 second, you can catch a segment of a fast moving subject that is ordinarily too quick to see with your eyes. The picture of the lacrosse players vying for the ball (opposite top), taken at 1/1000 second, is a good illustration of this point. Thanks to a fast shutter speed, I was able to capture that exact moment when all five players were, for a split second, looking at the ball before slamming into each other to try and gain control of it.

Another fleeting point in time is seen in the middle image to the right, where I captured a dynamic moment between two horses racing on an Irish beach near sunset. A shutter speed of 1/1200 second froze the gallop and sprays of water in details beyond our capacity to see. Notice how this fast shutter speed even freezes the individual droplets of water. The same shutter speed has a similar effect on the water spray of a surfer's board in the bottom photo (right). It is this unique ability to catch and freeze moments of time that are normally too fast for us to see that gives the stop action still image so much of its dramatic power.

as it falls (polar bear above, at 1/125 second) or let it have downward motion (the deer at 1/15). Notice also how the diagonal direction of the snow in the Polar Bear picture is a subtle cue that there is a wind blowing. This is even more pronounced in the bottom example, which I took during a windy snowstorm in Bryce Canyon, Utah. In contrast, the straight downward streaks of falling snow in the deer picture indicate a

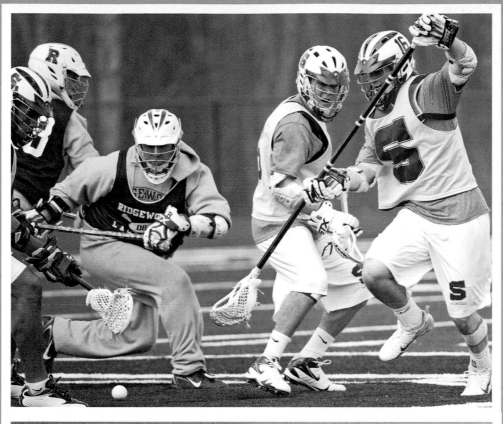

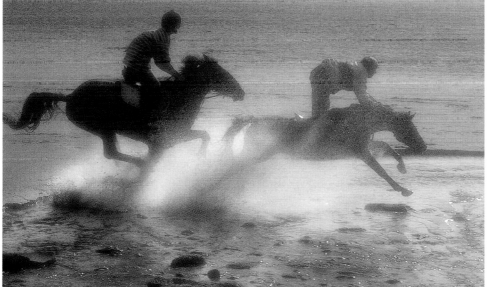

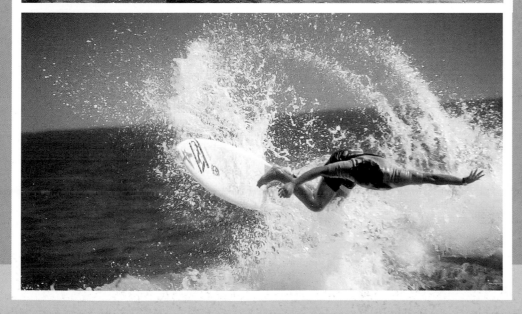

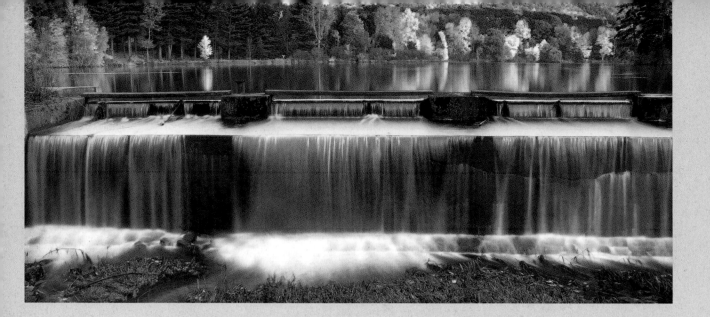

When a slower shutter speed is used, movement will be transformed into a blur. Visually, we associate this effect with something moving and, therefore, the passage of time. The example above is a typical case that shows how a slow shutter speed of 1/10 second with a camera on a tripod can turn water going over a dam into silky streams, forming a blurred path. This is also what has happened in the example at lower left where a 1/15-second exposure produced a blur trail of the baseball into the catcher's glove. In this case, the contrast with the lack of significant movement from the subjects, gives the distinct impression of speed.

Slow shutter speeds present a moving subject as existing over time with clues denoting how fast the movement is occurring. This can be seen yet again in the middle image below, where the extreme blur created by setting an exposure of 1/10 second was used

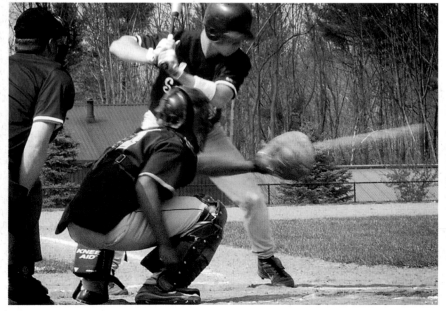

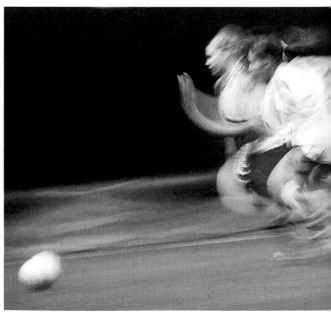

to capture these soccer players chasing the ball. Notice how the last player seems to be recorded in more than one place in the picture, indicating the passage of time.

Yet another approach that conveys movement is seen in the lower right photo, where a zoom lens was used to quickly change focal lengths during a 1/4-second exposure. The resulting streak pattern reinforces the feeling that the band members are marching forward while playing. And in the example to the right, it is again a streak pattern that gives the impression of the speed of this rodeo rider, but this time it was caused by following the rider with a camera set at a slow shutter speed of 1/15 second.

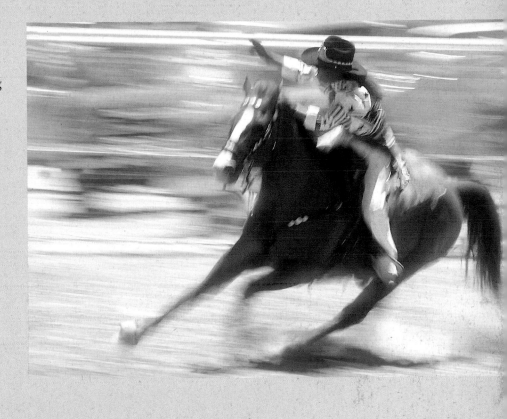

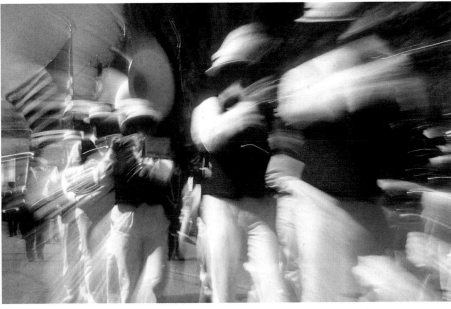

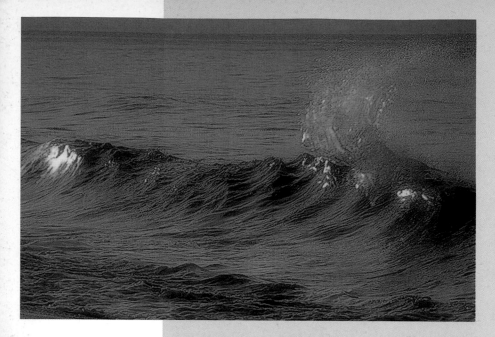

when a five-minute exposure is set for the surf shot in the photo below. This long exposure also turned the headlights of cars on the highway in the far background into long light-trails. The overall result is a completely different rendering of the waves. Such effects are contrary to the way humans perceive motion, since we cannot extend time into a blurred image. When recorded like this, the viewer is able to discover a very different representation of motion extended over time through its depiction in the still photograph.

As the shutter speed is set ever slower, producing more and more of a blurring pattern, there is a loss of the subject's distinctive shapes and textures. For example, compare how the characteristic curl and spray of the waves clearly seen in the picture above, photographed at 1/125 second, are lost

Subtle Uses of Shutter Speed

While the most familiar technique in motion photography is to affect the whole picture by using an extraordinarily fast or slow shutter speed, it is certainly not the only approach. A creative and technically knowledgeable photographer can also utilize more subtle degrees of shutter effects, as I first suggested in the discussion about photographing falling snow (see page 17). For example, you can choose a speed that both stops some action in the scene while also allowing faster-moving aspects to blur. This is the case in the photo to the upper right, where a native Greenlandic singer is accompanying herself by beating a drum. A 1/125 second setting renders her general body movements in sharp focus, except for the fast hand action of beating the drum.

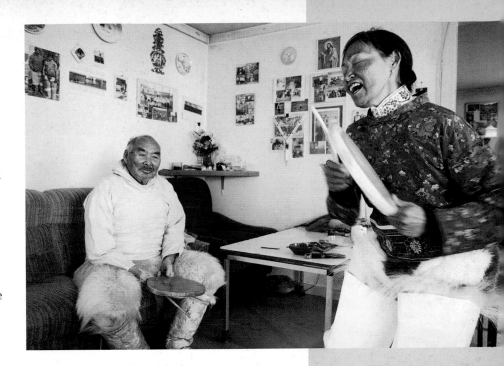

In the next example, the young baseball pitcher was caught with a shutter speed of 1/200 second that was just fast enough to render his moving body reasonably sharp, but not fast enough to freeze the throwing arm. This result makes a clear visual statement between the comparative speeds of the whip-like throwing motion of the arm versus the forward movement of the pitcher's body. The separation of action in these two examples would have been lost if a faster shutter speed froze all action or a slower shutter speed merged body and limb movements into a common blur. Such selective, subtle control of the way in which movement is represented shows the range of results you can achieve with this basic camera function. This is the photographic language of motion and time necessary for understanding what the aesthetic impact of rendering movement within the composition will be. Chapters 4, 5, and 6 cover all these aspects of slow and fast shutter speeds in greater detail.

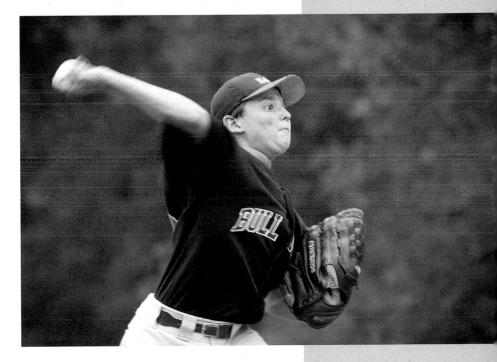

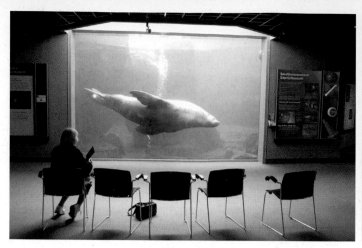 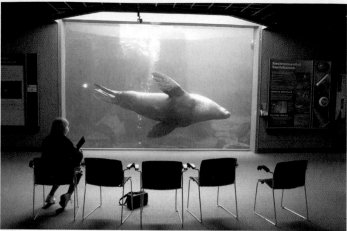

Timing and Anticipation

No discussion of the concept of time and ways to depict motion can be complete without considering the role of timing and anticipation on the part of the photographer. Such skills are best developed and honed through practice, and there are some specific techniques that can improve these skills. For example, one of the best approaches is to examine not only your successful pictures, but your failures as well. In this way you can analyze your progress in anticipating the right moment to take a picture. A great advantage of digital photography is the metadata that can be imbedded in each image. In particular, you can review the shutter speed and aperture used as well as the focal length of the lens. This extremely useful feedback is detailed more in Chapter 3, which is about optimizing camera settings for motion work.

Developing a sense of timing occurs on many different levels. Sometimes, timing is simply a matter of having enough patience: That is, waiting for just that moment when your subject has reached the pose that is the most expressive of the motion involved. This was the case in the examples above of a sea lion that swam by the front of the tank repeatedly. As I watched each pass, I noticed the animal would spread its flippers fully at different points in the tank, so my goal became to capture that exact point when the sea lion's flippers were fully open (right photo).

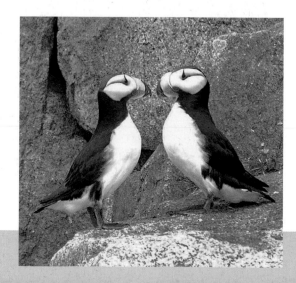

In the photo of the birds (opposite, below), I waited for the Puffins to line up and face each other just an inch apart. Again, it was a matter of patience as they approached and backed off from each other a number of times until the close proximity I anticipated finally occurred.

Other situations certainly require faster timing and, certainly, luck is often involved in getting that extra-special picture. The basketball players to the right required fast timing to catch them in the air reaching for the ball, but I was also lucky to capture the player on the floor looking up at them. And in the examples below, timing and a little luck resulted in a couple of unusual moments.

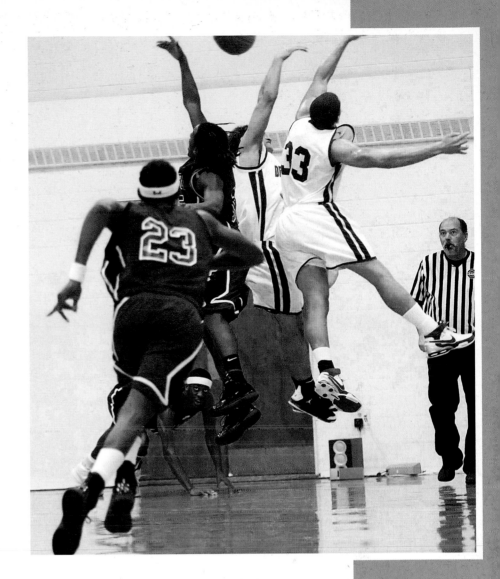

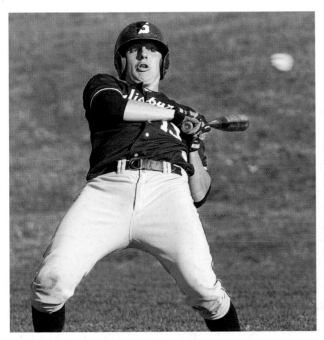

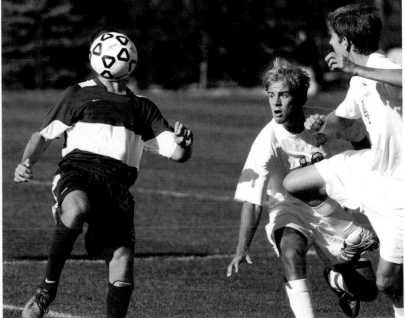

Software

The emphasis in this book is to illustrate the capture of time and motion in the camera at the point when the picture is taken. There are also situations, however, when various software techniques can be used to enhance what has been captured. Of particular interest are those techniques that can selectively add a greater sense of speed, such as the blur filter used in the picture of the baseball player passing out of the frame in the top example to the right. In the lower picture, a sense of movement has been added to an action situation originally captured with a fast shutter speed. At 1/500, the shutter speed was fast enough to freeze the struggle during a tackle. Then, a spin filter was applied around the edges to convey the motion of that struggle. The use of spin, zoom, and other motion filter applications are pointed out through several examples found in Chapters 2 and 5.

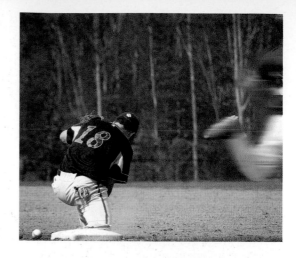

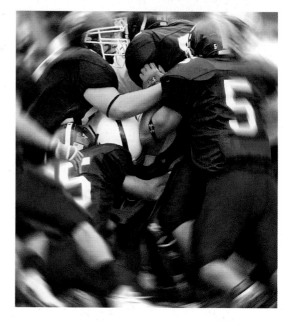

An original nighttime image of a water skier, captured by professional photographer Zenon L. Bilas in the top photo on the opposite page, has been given an X-Ray filter treatment in Tiffen's Dfx software for a truly unique look. Bilas' work and his methods are examined in a profile found on page 108.

Finally, not all special effects are the product of software applications. Indeed, there are several special effects techniques that can be done in-camera. One form I call "freestyling" is shown in the example at the bottom of the opposite page. In this technique, the camera is moved during a long exposure (1/10 second in this case) to form streaks. I took the lower photo on the

opposite page while my plane was in the approach pattern for a night landing. I moved the camera quickly from left to right and then stopped to complete the 1/10-second exposure.

If you add occasional post-production software refinements to the skillful use of shutter speed manipulation, compositional devices, the influence of lens focal length, aperture, and perspective, it quickly becomes obvious that there are many opportunities for personal expression.

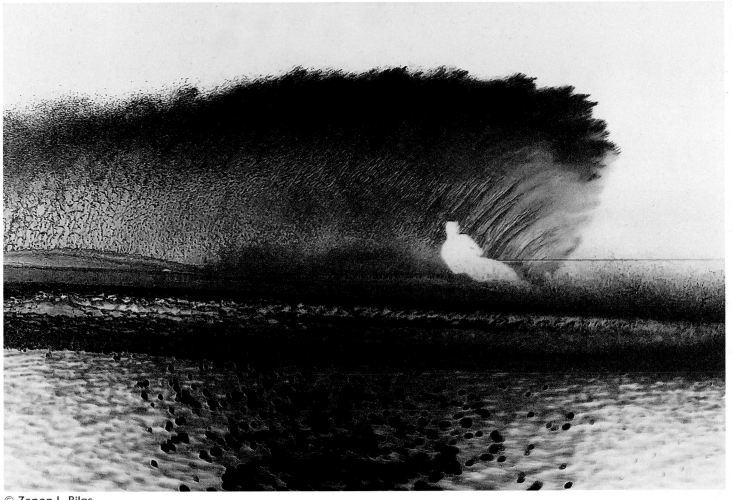

© Zenon L. Bilas

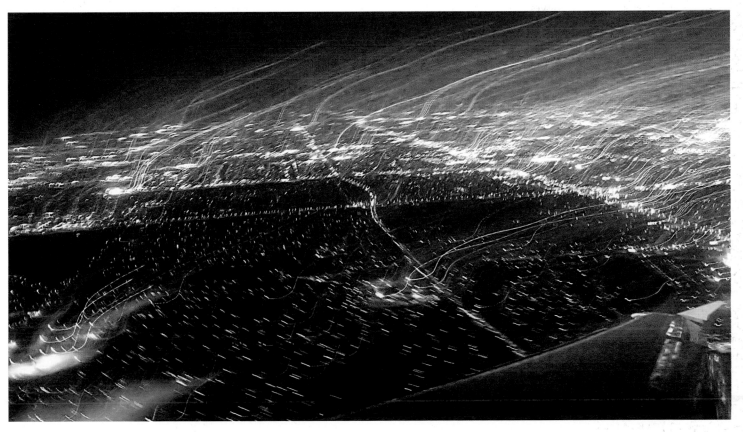

Profiles

Eadweard Muybridge (1830-1904): Motion in Sequence

Let's consider how some of history's master photographers have used the techniques and concepts that form the photographic language of time and motion to create their unique representations. These five men do not make a completely comprehensive listing, but each has made significant contributions to this genre.

Eadweard Muybridge migrated to America from England in the mid 19th century. In 1872, a job came his way that would forever establish him as a photographic pioneer in the mechanics of motion. The former Governor of California, Leland Stanford, asked Muybridge to take pictures of his prized racehorse, Occident. The purpose was to answer the age-old question of whether or not all four legs of a horse left the ground at the same time during any point while the animal was trotting. Such an assessment was beyond human vision to determine, so Muybridge arranged a series

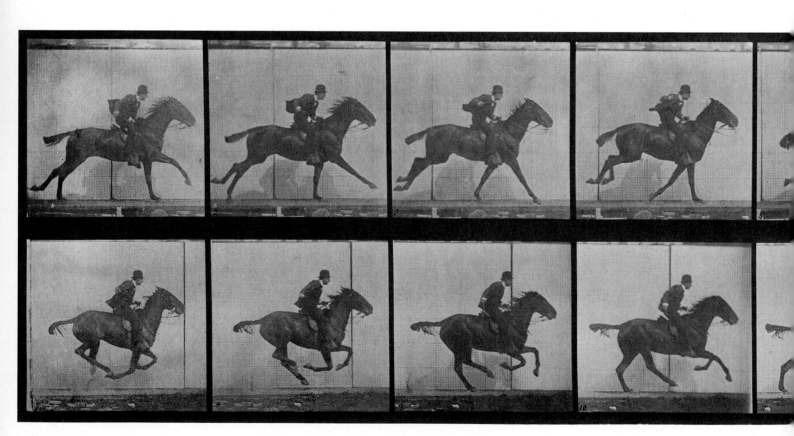

of separate cameras in a long line against a large white background. The trotting horse was then captured by each camera in succession to produce a sequence of frames at approximately four per second. The results, along with many other sequence studies, were published in Muybridge's "Attitudes of Animals in Motion" in 1881. In these studies, he clearly showed that all four legs of horses do, indeed, leave the ground simultaneously at some point. Muybridge, considered by many to be the "father of the motion picture," photographed a number of motion sequence studies using subjects that encompassed different animals as well as humans, and later went on to develop the Zoopraxiscope moving picture projector.

Muybridge's collection of sequence photographs isolate various kinds of motion in segments or cycles from the beginning of an activity to its ending. In short, he was recording motion over a period of time. Anyone who examines Muybridge's remarkable work will learn much about the cycles of movement and stages of transition in common motions. In particular, it is a primer for those who photograph fashion models, sports figures, and dancers, essentially dissecting how the body moves. Muybridge's studies can help sensitize the photographer's eye to look for those moments when the subject is in the most desirable position. It also shows how a subject can appear differently as a result of rather ordinary and often subtle movements. Just think of pictures taken of people in which they have been captured in uncomfortable if not unflattering positions. For example, try sometime to record couples on a dance floor so that none look awkward when transitioning between different dance moves. Many wedding photographers have learned that the safe way to get such a picture is to ask everyone to freeze. Invariably, the people will take up a complimentary position for the camera.

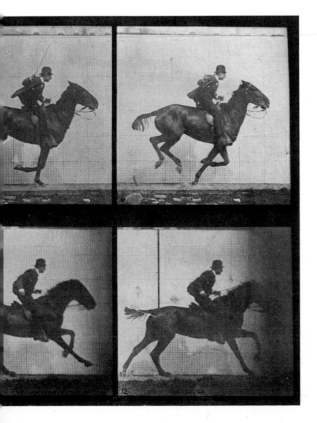

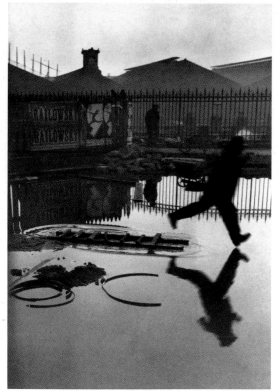

© Henri Cartier-Bresson/Magnum Photos.

Henri Cartier-Bresson (1908-2004): The Decisive Moment

The French photographer, Henri Cartier-Bresson, began his artistic career as a painter but turned to making photographs in the 1930s. His influence on photography is enormous, and I encourage you to research his contributions and study his images. Cartier-Bresson pioneered the aesthetic of the candid moment. His ability to see critical moments during the transitions of movement was a major contribution. He is considered the father of photojournalism and is a major contributor to the techniques that eventually became known as "street photography". Cartier-Bresson's approach is probably best summa-

rized by the phrase, "the decisive moment." As he exclaims in his 1952 book, *Images à la sauvette*, "There is nothing in this world that does not have a decisive moment."

Unlike Eadweard Muybridge, who was more interested in making accurate recordings of entire motion sequences, Cartier-Bresson's work delves into the aesthetic of transition with an eye to capture the most interesting moment. At the same time, he selected compositions that showed the viewer something about the total movement involved by including just enough of the setting. This obviously required a remarkable ability to see such opportunities coupled with an artist's sense of composition and timing. Even the most superficial examination of his work will indicate how Cartier-Bresson was a master at using photography to capture the unique quality of human movement, versus Muybridge who strove to record the individual movements of an entire motion sequence.

You can see a comprehensive collection of Cartier-Bresson's photos on the Internet by going to www.magnumphotos.com; click "Advanced Search" at the top of the display, then go to the dropdown for "Include Photographer" and select Cartier-Bresson.

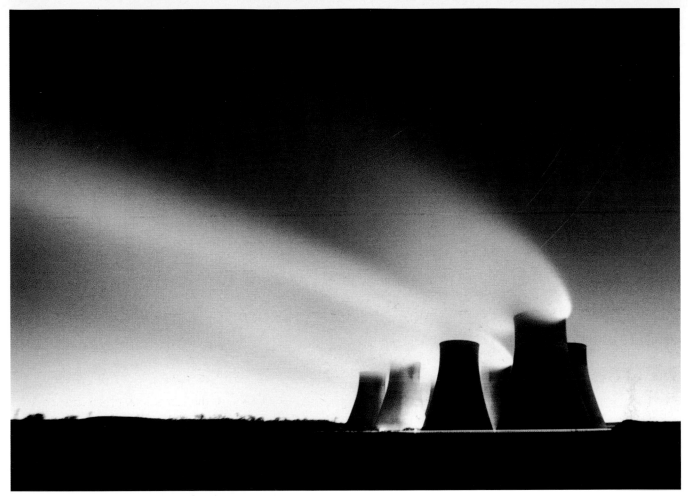

Ratcliffe Power Station, Study 26, Nottinghamshire, England, 1986. © Michael Kenna.

Michael Kenna (1953-):
Extended Time and Motion

Some of Michael Kenna's most famous photographs show huge power plant cooling towers taken with a continuous exposure spanning the hours from dusk to dawn. The results have been variously characterized as otherworldly and dream-like. It is clear that his extended exposures move people out of their normal ways of seeing the world. In that sense, Kenna has used time as its own visual element, giving his pictures a third dimension of expression. Though his subjects and treatments range widely, one of his most significant contributions has been to demonstrate how the world can be portrayed using extended passages of time. As a result, there are no humans in these images since none ever stand still long enough to be recorded. Rather, there is interplay between the stationary and the slow moving subjects or elements in the scene—such as cooling towers and the movement of such things as clouds, smoke, and lights over relatively long periods of time. Again, the themes of motion, transition, and cycles are at work, using a treatment and artistic interpretation in which the passage of time is the dominating element.

Jacques Henri Lartigue (1894-1986): To Jump and to Fly

The earliest years of photography are full of contributions made by the work of devoted amateurs. That is, people who may have sold some of their work but generally produced pictures for non-commercial reasons. The early photographs of French painter and photographer Jacques Henri Lartigue fall into that category, with his greatest commercial photographic successes coming later in life when he was in his 60s. The son of wealthy parents, he had access to the upper crust of French society, which he documented with his camera from the young age of six until his death at age 85. Better known to the art world throughout most of his life for his painting, Lartigue loved to photograph racecars and races, including such famous competitions as the French Grand Prix. He was also fascinated by the movement of people. While he had access to the best equipment of the day, his early photos of high society denizens in motion are, nevertheless, remarkable achievements both technically as well as aesthetically, for there were no motor drives, fast films, or on-camera flash units through out most of his early career. He had to record a single exposure at that perfect moment.

In the words of Lartigue's biographer, Kevin Moore, " . . . [for] all the jumping and flying in Lartigue's photographs, it looks like the whole world at the turn of the century is on springs or something. There's a kind of spirit of liberation that's happening at the time and Lartigue matches that up with what stop action photography can do at the time, so you get these really dynamic pictures." Thus, Lartigue used motion as a means of portraying his subjects breaking free from their previous generation's tightly regimented and codified society. Once again, an artist turned to motion and time as the means of producing something quite different from the conventional portraits of that period. You can find examples of Lartigue's work on the Internet at www.lartigue.org/us2/donation/agence_photo/index-themes.html

Harold E. "Doc" Edgerton (1903-1990): Motion in a Flash

Harold Edgerton was a professor at the Massachusetts Institute of Technology for his entire professional life. He used photography as a tool for capturing segments of high-speed motion such as the windmill movement of a golf swing or a bullet bursting a playing card or apple. What made this possible was his ability to generate flash speeds in the range of 1/1,000,000 second. Edgerton is credited with inventing ultra high-speed stop action photography. Every photographer who uses a flash unit today owes a debt to Edgerton, for it is he who gave us the ability to freeze action with short bursts of intense light. But as he once stated: "Don't make me out to be an artist. I am an engineer. I am after the facts, only the facts." Nevertheless, he produced some of the most remarkable time-motion photographs ever made.

What Edgerton clearly demonstrated was how much of the world of motion is beyond our vision. His inclusion in this chapter is intended to set the outer boundaries of how much we do not see of this world and how speed and time rob us, if you will, of seeing a good part of our world. While he may have avoided the label of artist, he clearly was showing us the world differently—and isn't that precisely what artists strive to do?

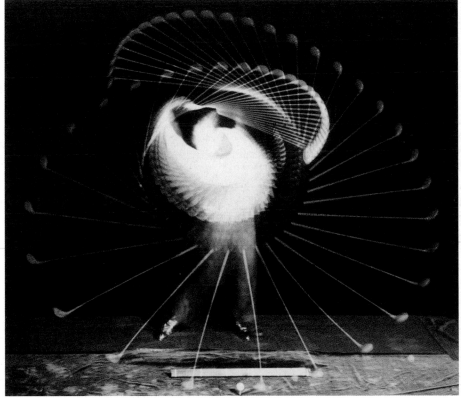

© Harold & Esther Edgerton Foundation, 2009, courtesy of Palm Press, Inc.

2 Composition in Motion Photography

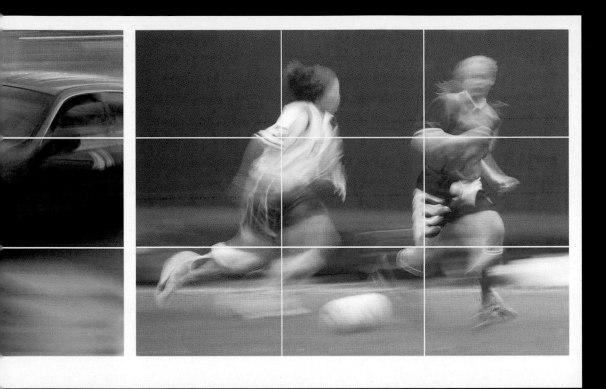

The basic principles of photographic composition have evolved from those previously established in the fine arts, especially drawing and painting. Anyone who has taken an art history course, or has tried their hand at painting or sketching, is familiar with such concepts as framing, the rule of thirds, horizon line, dynamic balance, leading lines, etc. All of these and other fine art constructs are also part of photography's composition lexicon. In addition, as pointed out in the opening chapter, photographers can influence a composition by controlling the visual relationships between foreground, subject, and background through the selection of focal length (compression and decompression) and aperture (depth of field). Furthermore, not all of the traditional concepts of composition are useful to the motion photographer. Some are even counter productive, while there are also compositional devices that are unique to motion photography.

The Rule of Thirds and the Frame

The best way to sort all this out is to start by looking at the conventional compositional arrangements that serve the motion photographer's purposes while adding the influences of focal length, aperture, and camera position. Then we will look at the unconventional approaches that can be used to strengthen the elements of movement and the concept of time in photos.

Two of the most basic concepts in photographic composition are the frame, which outlines the scene, and the rule of thirds, which influences placement and picture balance. In photography, the shape, or aspect ratio (width:height), of the frame is set initially by the shape of the sensor. What can be recorded in that frame is determined by the angle of view of the lens as controlled by the focal length. The digital photographer then has the option to crop the scene later using computer software, and establish a different framing as well as a new aspect ratio. We will come back to this framing and cropping step in a moment (see page 41).

The rule of thirds refers to the equal division of the image frame into horizontal and vertical thirds as seen in Figure 1 (left). Placing the subject at or near one of the four "power points" where these lines intersect generally gives the subject a stronger visual presence compared to other areas in the frame. (See how the merry-go-round horses are placed at the two lower intersections, above right.) Most photographers (myself included) will use this rule as a useful guide for arranging a composition. However, when it comes to motion photography, the principles underlying the rule of thirds sometimes have to be "bent" in order to accommodate the flow of movement in a scene.

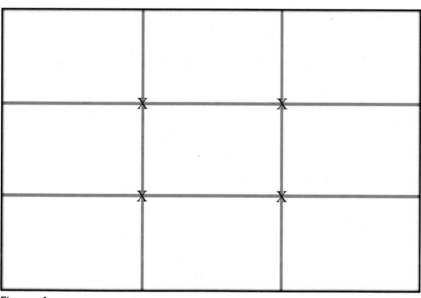

Figure 1

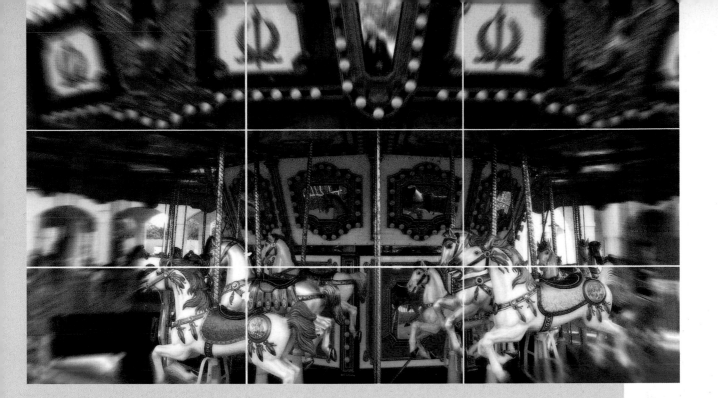

The Direction of Motion

If the rule of thirds has one truly practical purpose, it is to encourage the photographer to avoid stagnation by not placing a subject in the dead center of the frame. Why stagnation? In a traditional arrangement, the eye of the viewer is naturally attracted first to the strongest visual element in the picture, which should also be the main subject. By placing this element at one of the power points, the photographer is not only reinforcing its importance, but is also facilitating the tendency of the viewer's eye to move from the main subject to search the rest of the frame in an effort to take in all the visual information—a sort of second phase of viewing. An effective composition will help direct the viewer's eye through an organized and balanced visual presentation

that makes sense. Unsuccessful photographs are typically ones that confuse the viewer and do not clearly present the subject in context with the secondary content of the picture.

The dynamics of the rule of thirds with its emphasis on placement, direction, and balance have several important implications for the motion photographer. As pointed out in the previous chapter, unlike static arrangements, subjects in motion will often have an extra visual quality—the direction of the motion. It is important to recognize this and deal with it effectively within the framework of the rule of thirds in order to strengthen the impression of the motion. The easiest way to do this is to provide space within the frame for the implied motion of the subject. This space can either be where the subject is going or where it has come from. Some examples are pictured on the following pages.

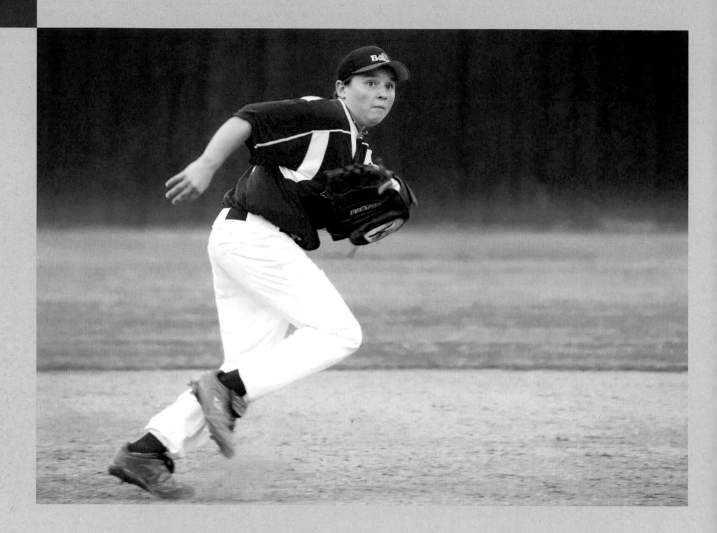

The young baseball player above is running to field a ball to his left (viewer's right). I framed this shot in the camera almost as it appears here, with very little cropping later in the computer, using a zoom lens set at 190mm. The aperture of f/2.8 produced a shallow depth of field to help isolate him from background elements that might come into the picture as the camera followed his movement. At the same time, I wanted just a hint of motion, so the camera was set on Shutter Priority exposure mode at 1/125 second, which is not fast enough in this type of situation to freeze his running motion completely. As a result, there is just a small amount of blur in the feet. The extras that really make this shot work are the player's intense expression and position of his leg that I caught mid stride with his body leaning forward. All these points, plus allowing open space for his direction as he moves toward the right half of the frame, help to visually support the motion taking place.

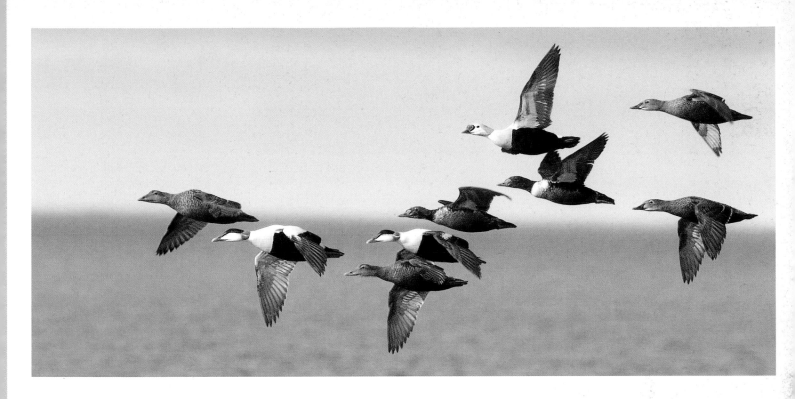

The composition of the geese in flight (above) is more complicated. I couldn't hope to arrange these birds in exact accordance with the rule of thirds, but I could ensure that the flow of their forward motion was included. Later in the computer, I changed the aspect ratio from that of a full-frame 3:2 ratio to a more elongated frame to further emphasize the forward motion. A 1/1000 second shutter speed was used to freeze their wings in mid-stroke.

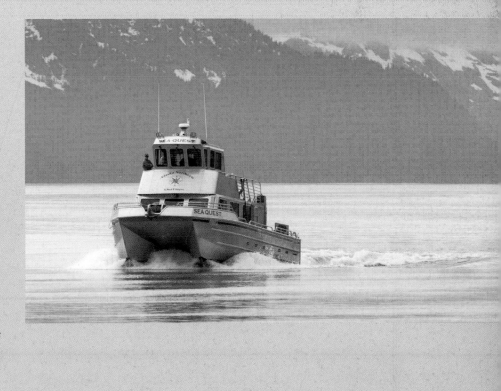

Usually, the direction of the implied motion is the forward direction where the subject is going. There are other times, however, when it is better to give emphasis to where the subject has been. The photo at right, shot at 1/250 second, is a typical example of a more subtle use of this option, giving a bit more space to the wake of the boat.

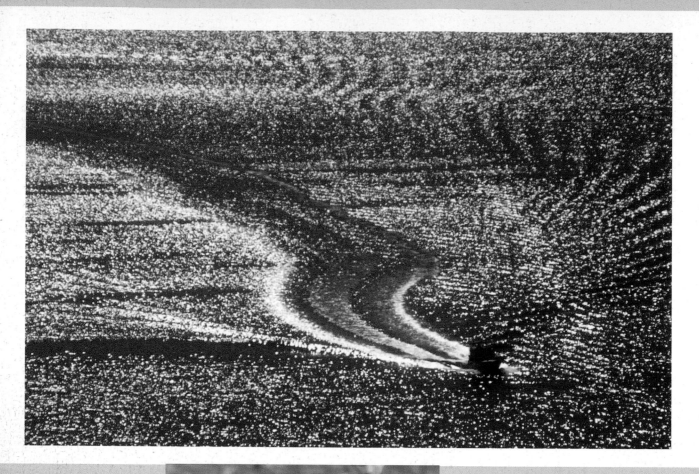

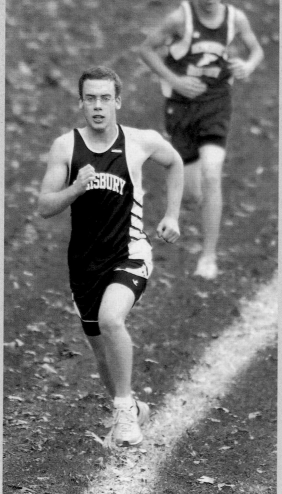

A much greater emphasis to the path already traveled is seen in the other boating picture (above). This image was taken from a tower overlooking Cape Cod Bay with a 105mm lens at 1/250 second to freeze the long wake of the boat.

The photo of the cross country runners (left) incorporates secondary visual elements that help show where the runner is going as well as where he is coming from. The white course line set diagonally in the picture helps establish a strong sense of the direction in which he is heading. At the same time, the runner behind reminds you where the lead runner has come from. These factors work together very nicely in this vertical format shot with a 300mm lens at f/4.0 and 1/500 second.

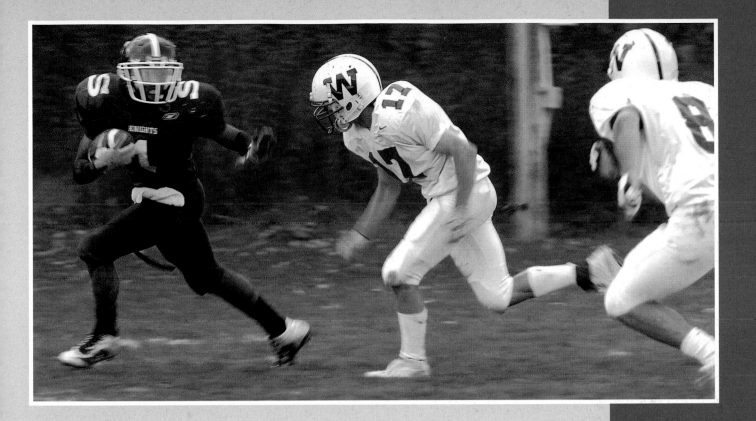

Framing and Cropping

There are also times when the direction of the motion in a scene turns inward. For example, examine the three football players (above). While the ball carrier is moving toward the left of the frame, the more important flow of movement is actually in the reverse direction as established by several visual clues. First, the ball carrier's head is turned opposite to his forward motion in the direction of his closing pursuers. Second, the two defenders are not moving so much to the left as they are toward the ball carrier. Consequently, in this case, tightly cropping the front of the ball carrier adds to the impression that he is going to be cut off and tackled in the left third of the frame near the power points in this area.

As mentioned earlier in this chapter, a photograph is initially framed according to the aspect ratio of the camera's sensor (that is, the width divided by the height of the image expressed as a ratio). In DSLRs with full-frame 35mm-sized sensors, the 36mm x 24mm frame produces a 3:2 aspect ratio, whereas a 4:3 ratio is common in digital point-and-shoot cameras. The angle of view of the lens, ranging from wide-angle to telephoto, controls the image that actually fits into the frame.

During the final cropping, as demonstrated in the example of the geese in flight (page 39), the photographer has the option to alter the aspect ratio to help support the direction of a subject's motion. Thus, cropping is a means by which the photographer can further define the subject and emphasize the

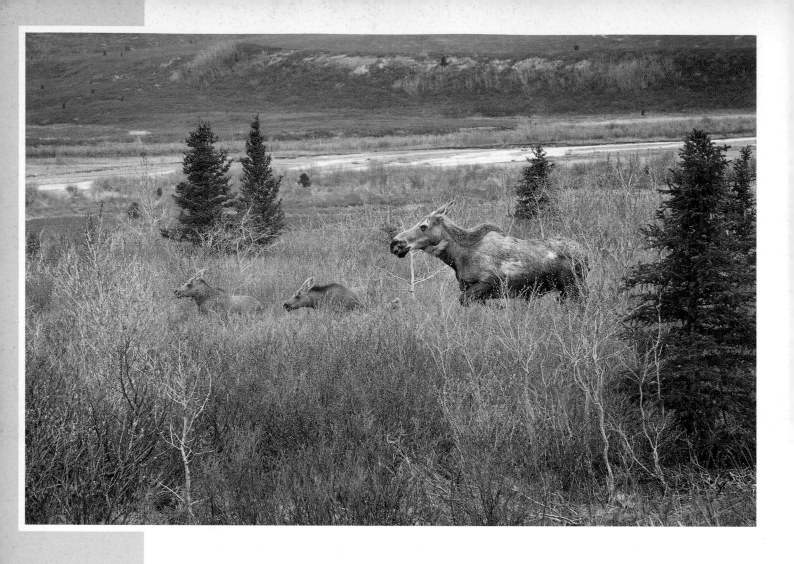

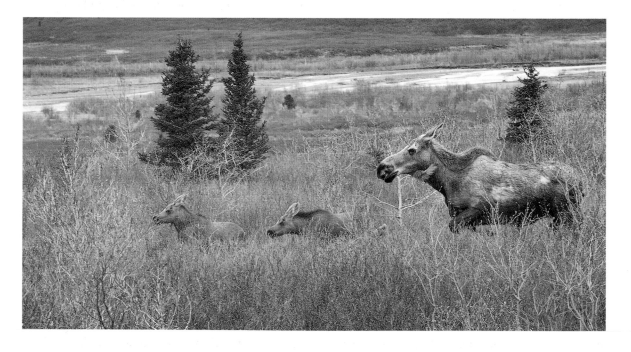

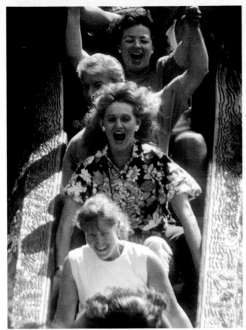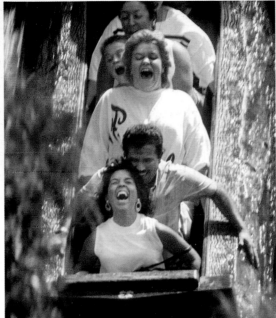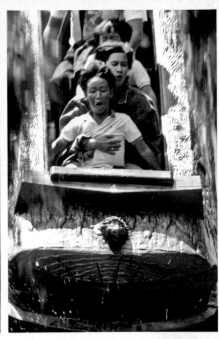

direction of the motion. In short, framing at the point of taking the picture and post-production cropping are both extremely valuable ways a photographer can refine the importance of motion in the final frame. Some examples of cropping for effect are found on these pages.

The top photo on the opposite page is an original shot of a female moose with her two calves running from a grizzly bear in Denali National Park, Alaska. It was shot through the window of a guide bus with a zoom lens at 85mm, 1/250 second, f/6.3. The trio was moving so quickly that I really had no time to compose beyond placing the main subjects in the middle of the frame. Later, in the computer, I cropped the image to give more emphasis to the forward flow of motion as seen in the bottom photo.

Deciding what to put in a frame and what to exclude at the time the picture is taken can be a difficult decision, as it was for the moose and calf image. I have found that many times I frame too tightly in action situations and later regret my choices when it is time to select final images. So, I have adopted a technique in which I force myself to include a bit more of the scene than I originally think I should.

The three frames above provide a good illustration of this point. The people in all three photos have great expressions, and the slight blurring gives a sense of motion. But why are they showing all this excitement? It is not until possibly the middle frame, and definitely in the last frame, that we see they are all in a log-shaped amusement park ride moving steeply downward. It is easy to get carried away by the excitement of trying to capture a fast moving situation. Nevertheless, it is

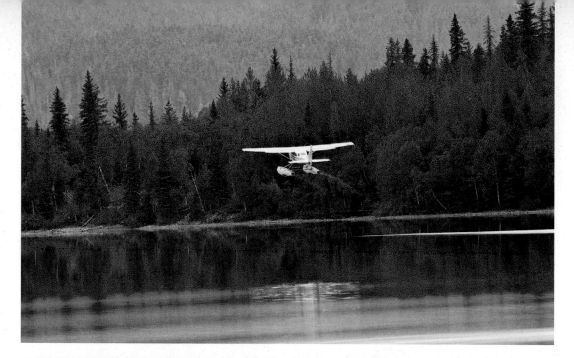

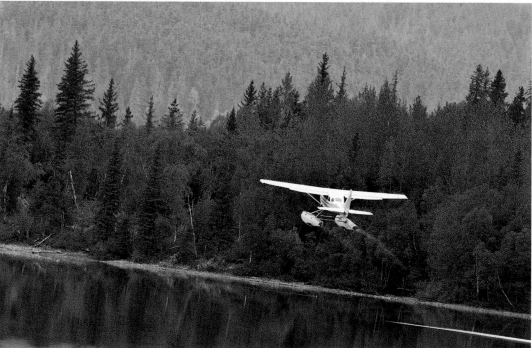

important to think in terms of the whole picture, always asking yourself: What am I trying to do in this situation? Just capturing the main subject's motion may not be enough for a full and balanced statement.

Cropping later in the computer can correct some oversights that occurred when the picture was taken. In the top photo above, the original capture of a float plane shows that I tipped the camera in a downward direction opposite to the plane's take off, and also placed the subject dead center in the frame. The crop in the lower version places the plane turning upward, plus more emphasis has been given to the direction of the plane's flight path. This is a more dynamic presentation of the plane's take off. Fortunately, I did not frame the plane tightly and had enough frame space to improve the final image.

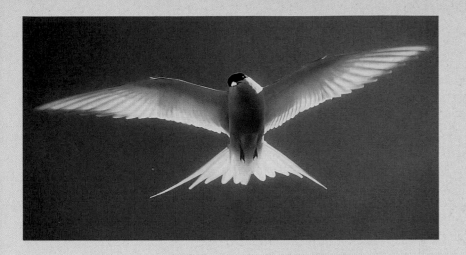

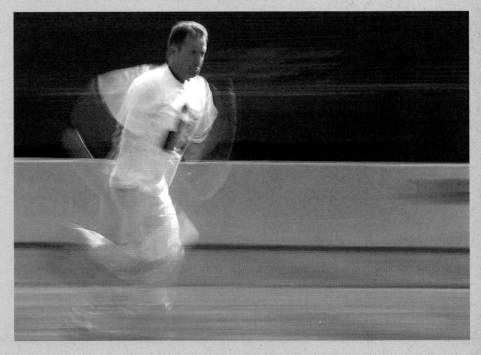

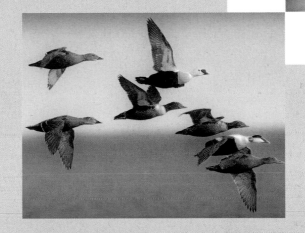

Horizon Line

The horizon line refers to the part of the picture that divides the frame between upper and lower segments. In a landscape composition, the horizon line typically divides sky area from the land below, or from a body of water such as an ocean or a lake. In the float plane pictures (left), the horizon line is the division between the surface of the lake and the base of the trees. Also, as seen in those pictures, the horizon line indicates whether or not the camera was held level in relation to the scene. Other lines in a picture can also act as horizon lines, such as the dividing point between a meadow in the foreground and the base of a mountain in the background, for example. There are also times when there is no horizon line, as in the top picture above, where a Tern was photographed against a plain blue sky, or scenes where the line in the background is faint, as in the picture of the birds in flight (above middle). And not all horizon lines are created by nature, such as the man-made environment in the photo of a runner (right), where the grass line meets the barrier in this 1/10-second exposure.

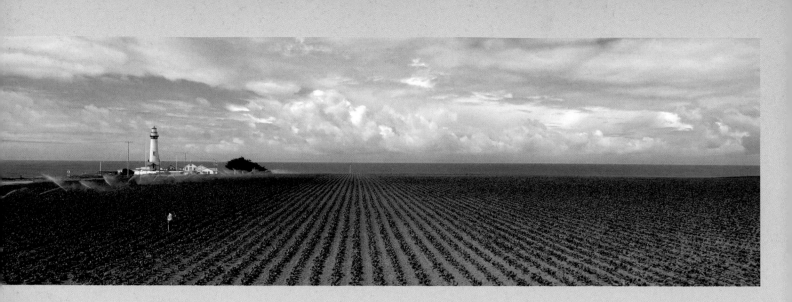

In addition to keeping subjects out of the center of a frame, the rule of thirds also discourages you from placing the horizon line in the center, which would evenly divide the image in half, discouraging visual flow throughout the scene. This becomes less of an issue as the aspect ratio elongates, as seen in the truck example in the opening chapter (see page 12). In fact, a horizontal panoramic composition, with its extremely elongated view, will often have a horizon line at or near the center, as seen in the photo of the lighthouse and farm (above). This is because horizontal panoramic images often place the key elements across the length of the of frame space that dominates the center third of the picture.

In general, however, landscape photographers use a level horizon line and divide the scene according to the rule of thirds as seen in the crashing waves (right, above) taken close to sunset off the Schoodic Peninsula in Acadia National Park, Maine.

It was a day when a hurricane had just brushed the coast, producing large waves. I composed my shot based on the background and on the rocks in the foreground, plus the dramatic sky. I then waited for a wave to crash and dominate the left third of the frame. My intention was to freeze the water by using a shutter speed of 1/1000 second, so that even the droplets could be distinguished. Because of the failing light, I had to raise the ISO to 800. I waited for the wave to just about reach its peak and then pressed the shutter release. It took about ten trials to finally get this picture.

For the photography of motion, however, the horizon line is best used to help set up a dynamic balance between the upper and lower portions of the frame, in which case level arrangements are not always the best choice. Tilting the camera for a diagonal frame often lends an additional dynamic quality, or even a sense of tension, as seen with the horse-jumping photo to the right.

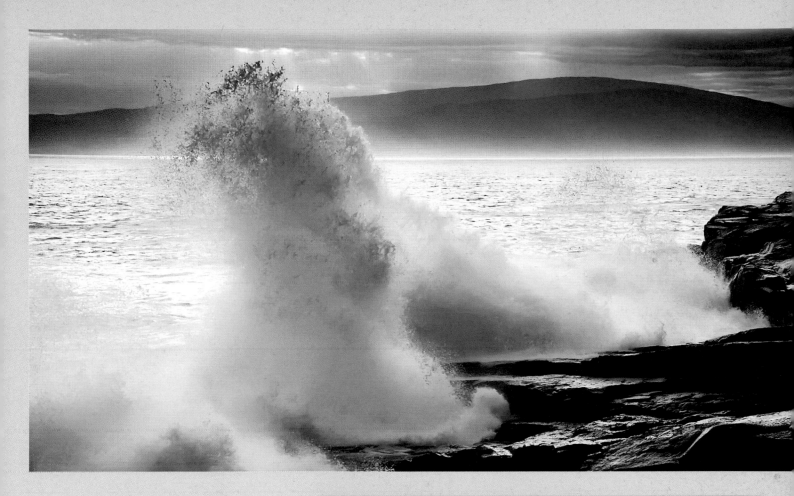

Here a dynamic angle helps reinforce the motion of the horse going over the fence. A 200mm lens was used from about 50 feet (15.25 meters) away. I set the lens on manual focus at f/8 to cover the subjects with enough depth of field, while the shutter speed was set at 1/500 second.

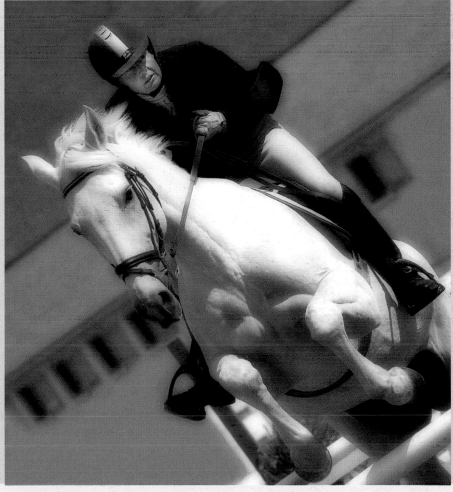

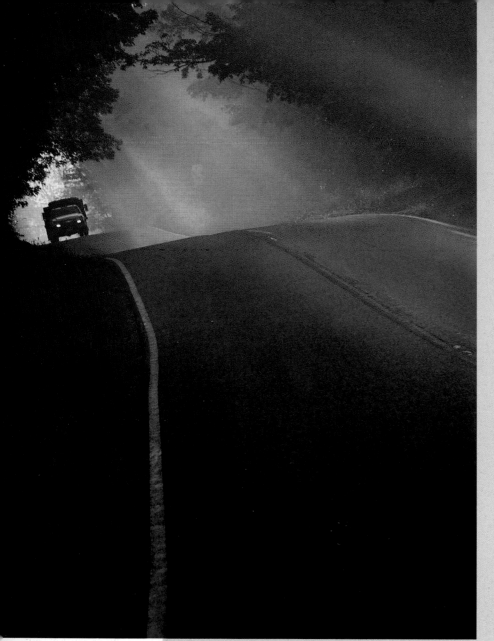

Stationary Objects as References

Experienced motion photographers are aware of including visual clues in a scene to reinforce a sense of movement. The easiest way to do this is to include stationary objects. These serve as stable points of reference to the moving subjects in a photograph, and also indicate that time is passing during that movement. Michael Kenna's pictures of stationary cooling towers that stand in brooding contrast to the dramatically rendered moving skies are an excellent example of this concept (see page 31). Very often a composition almost automatically includes such areas; for example in a seascape when a slow shutter speed causes the movement of the waves to blur against the stationary and sharply focused rocks. But there are times when the photographer has to make a conscious effort to include a stationary point, as illustrated in the following examples.

An even more extreme example of this type of dynamic composition is seen in the wide-angle capture of the truck above. I set the camera low, knowing that the wide angle would exaggerate the size of the road in the foreground, giving a strong sense of frontal direction for the oncoming truck. The sun's rays further reinforced the direction of the motion, while the truck was kept sharp by using a shutter speed of 1/350 second. The dynamic angle made it appear as if the truck was nearly lunging over the crest of the hill.

In the top picture on the opposite page, photographed using a shutter speed of 1/30 second, the bars of a metal fence are used as a stationary frame for the moving cars. This picture was taken with an inexpensive point-and-shoot digital camera, and frankly, the shutter lag made it a very frustrating experience. Time and time again, I missed a good combination of cars coming under the overpass on which I was standing. Eventually, I was able to time the cars well enough to get this shot. A small amount of the Classical Soft filter in Nik Color Efex Pro software was applied in the computer.

Note the slight curvature of the fence caused by the use of the camera's wide-angle lens and the camera being held very close to the rails.

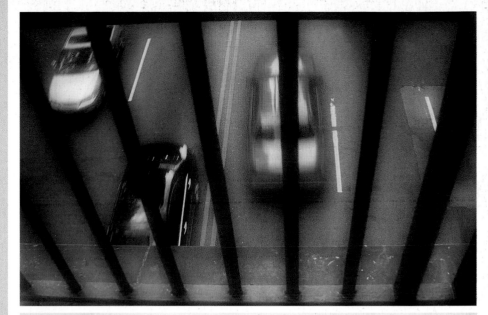

In the middle photo to the right, the boy in the foreground serves not only as a stationary reference point, but also as the main subject while he watches the African dancers. The camera was braced on the back of a bench using a 35mm lens setting and a shutter speed of 1/25 second to blur the dancers. I focused on the boy knowing that my aperture setting of f/4.0 would produce a relatively shallow depth of field, further softening the appearance of the moving dancers. Having enough patience turned out to be the most difficult part of this shot, since the boy kept changing positions. He stopped just as the dancers turned sideways and I was able to get the composition I was after.

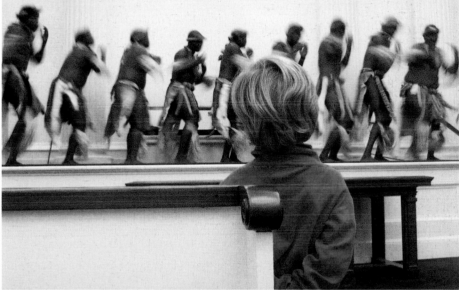

It was the high camera perspective in the photo to the right that allowed for the capture of the twirling dancers moving in a circle. I had originally photographed the scene with a fairly fast shutter speed, as the dancers were standing in place practicing individual steps. When they started to move around the musicians, I saw the possibility of catching a blurred circle effect. A shutter speed of 1/15 second in this type of situation produces the sense of motion around the musicians who serve as the stationary reference points.

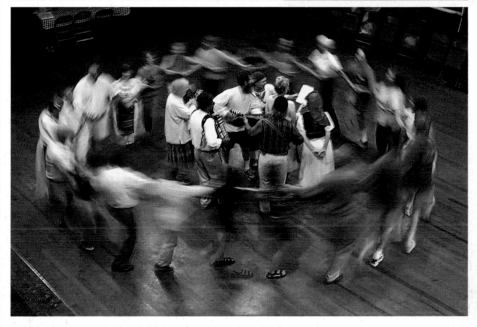

Anticipated Motion and the Dynamic Pause

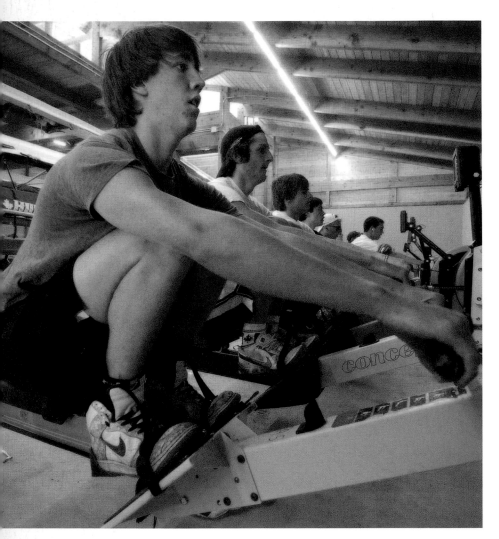

There is also a compositional technique that photographers use when motion is anticipated but is not actually taking place. Usually such situations occur under two different circumstances: One is just before the action is about to begin in a particular scene, and the second is at the exact moment when the action in a scene stops for a fleeting second before resuming. These choices are really about pressing the shutter when there is no motion. That may sound like a contradiction, but the captured moment is selected precisely because there is a sense of tension due to the fact that something is about to happen. What is common to these situations, and what differentiates them from a posed static setting, is the dynamic pause that is clearly part of some ongoing action.

To help understand how this type of dynamic pause conveys meaning, consider a vase of flowers sitting in the middle of a table. To any observer this would certainly be a static setting that gives no visual clue of motion. Photographing such a setting is appropriately classified as still life photography. Now position the vase so that a little more than half of it is hanging over the table's edge, giving the impression that it is about to fall. The feeling about the vase has now changed, so it is no longer a static

object but is now a potentially dynamic one. Even the words used to describe such situations communicate the feeling of imminent action. For example, "teetering" and "precarious" are apt descriptors indicating that motion is about to occur. Other examples include photographs that catch a startled person about to react to something, or a situation where a visual clue of tension—such as a facial expression or a posture—indicates that something is about to happen, such as the anticipation evident in the teenage boys ready to start a timed rowing exercise (opposite page). Typically, someone looking at such a picture will exclaim: "You caught him just as he was about to"

Capturing variations of the dynamic pause is quite different from using a fast shutter speed to freeze an action. In fact, very fast shutter speeds are usually not needed since there is typically little if any actual movement at that moment. On the contrary, it is all about recognizing that such an instant will occur and then recording it with one perfectly timed shot.

How does one capture such moments? Well, you have probably photographed such circumstances already without thinking of them specifically as an alternative way to represent motion (or a pause in motion).

This reiterates the importance of thinking about motion and time as a unique form of photographic language. Thus, success at capturing dynamic pauses requires the photographer to be sensitive not only to the flow of movement within a scene, but also to pauses in that flow. The first step is to examine the entire situation with an analytical eye. Recognizing such moments sometimes requires you to look away from the primary action to see what other circumstances may be involved in order to take advantage of them. The crowd's riveted attention at a critical juncture during a game may be more interesting than the action on the field. To get these sorts of photographs, you have to be aware of the whole scene and not just the parts that seem to draw the most attention.

The Pause in Stage Productions

Theatre productions are often permeated with pauses in the action appropriately referred to as dramatic pauses. Stage productions are designed so that the audience can clearly see what is happening. That is, the actors spend most of their time facing stage front following the adage to never turn your back on the audience. In addition, postures and gestures are often exaggerated so that the audience, no matter where they are sitting, can see what is happening. This is particularly true of musicals and dance productions often characterized by greatly embellished body movements and gestures. One great advantage to capturing a dramatic pause is having access to the rehearsals. Without having to photograph what is going on, you can concentrate on isolating the best opportunities for pictures and be ready for them when it comes time to photograph the actual production.

Here are some examples to illustrate several variations of the dramatic pause in stage productions and other performances.

In the stage photo (below left), I have caught a single actor holding a pose, a relatively easy shot if you know it is coming. But what gives this picture the sense of a dramatic pause is the fixated expressions of the three other actors. I saw this opportunity in rehearsal and captured it during the opening night using settings of f/2.8 and 1/125 second at ISO 800. The camera was used on a monopod.

In the picture below right, capturing the moment when this classical choral group paused to hold a note was not difficult, though it did take some effort to catch all of the singers in a similar pose. I had three opportunities to capture the moment, but

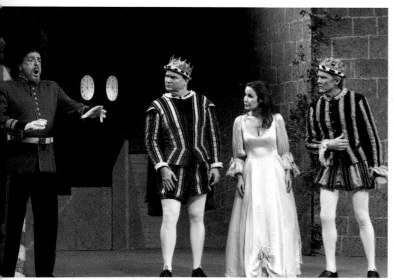
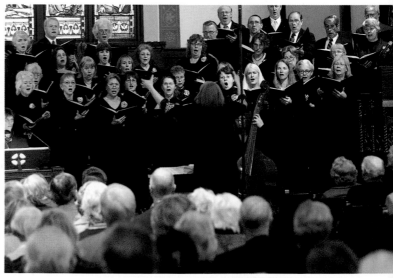

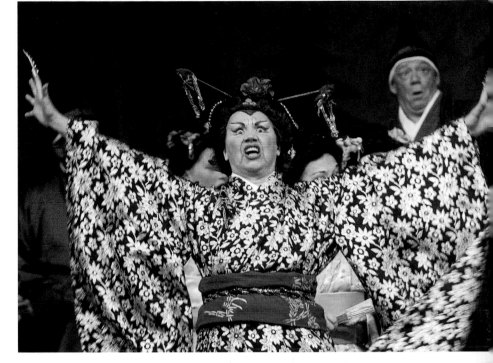

only the last attempt had virtually everyone with the same facial expression and with all eyes fixed on the conductor. I shot the picture at f/2.8 and 1/125 second was used with an ISO setting of 800. In general, smaller groups are easier to capture uniformly in a pause, especially if you can call for it during a set-up shot, as I did in the photo of the singing men's group (above left).

A dramatic pause in an exaggerated moment on stage will often capture the essence of a production. The actress in the photo above right has been caught at the height of such a situation, complete with exaggerated make-up and a wonderful expression representing the mocking humor of a Gilbert and Sullivan "Mikado" production. It is also reinforced by the comic look of the male chorus member just over her shoulder, a nice extra. A photographer has to be ready for such moments that, in this case, occurred at a point of transitional movement between the actress raising her arms in full extension but before quickly lowering them. This photo, recorded in relatively low light, needed an ISO of 1000, paired with settings of f/2.8 and 1/125 second.

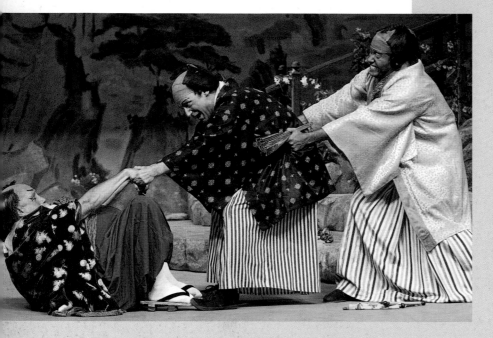

The action in the illustration to the left has stopped momentarily as the two actors prepare to pull together and lift the third one from the stage floor. Their exaggerated facial expressions convey getting ready to lift. Notice that the middle actor has braced his feet on top of the shoes of the actor on the floor, something I picked up observing the rehearsal.

The hardest dramatic moment to capture on stage is when the entire cast of a large production is involved, as in a scene from Gilbert and Sullivan's, "Iolanthe" (below). Again, if you have observed a dress rehearsal or know the particular play, you can be ready instead of having to rely on a chance shot. A fast 28mm wide angle-lens set at f/1.8 on a tripod was used at 1/125 second and ISO 800.

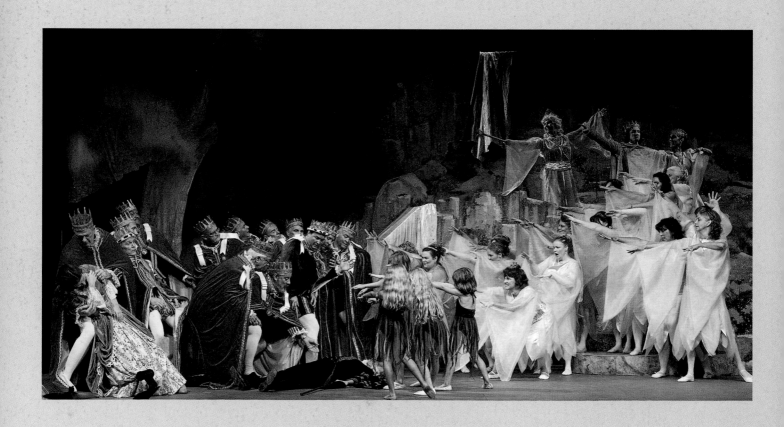

The Pause in Sports

Sport activities are a gold mine of dramatic pauses, especially in competitions where there are predictable and repetitive actions such as a pitcher winding up and throwing the baseball. There are also moments when the action reaches a point where everything seems to freeze for a split second as the players analyze what to do next. These situations, and many others, are opportunities to get a picture that captures a segment that says a great deal about the players and the game.

The wind-up of the young pitcher (right) during a youth baseball game has been caught at a moment of hesitation, just before the wind-up is complete and the ball is thrown. The dynamic tension at that point is similar to the example of a vase teetering at the edge of the table. In this example, a zoom lens was used at 250mm for a tight composition that did not include any allowance for the forward direction of the movement. The idea was a composition that would emphasize the tension of the pause just before the pending motion. A fairly shallow depth of field produced by a f/5.6 aperture setting softened the player who appears in the background, helping to emphasize the main subject. Because pitching is a repetitive movement, it usually does not take long to time a pitcher so that one shot will do.

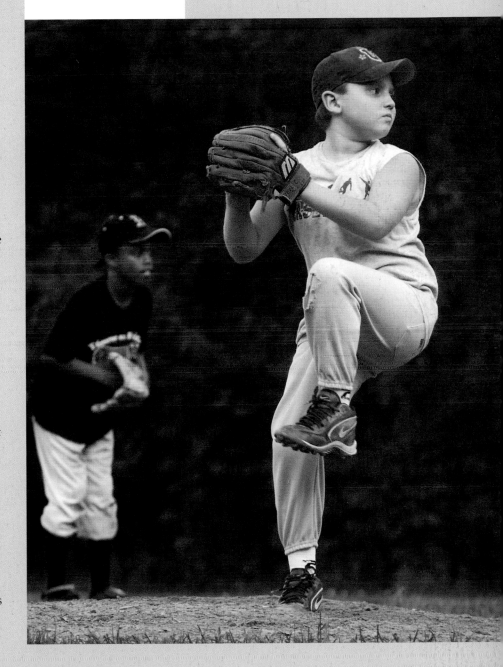

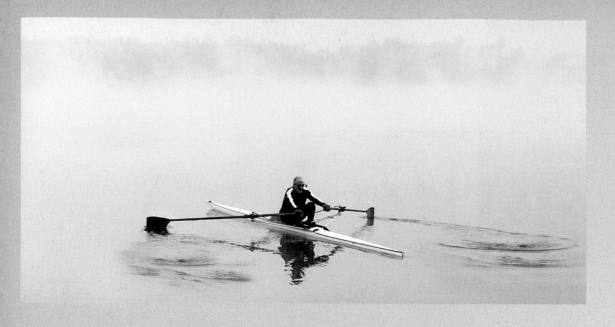

Sculling is another sport that demands very precise repetitive movements because there are several specific parts to each stroke. One segment, when the sculls (oars) have been turned perpendicular to the water's surface, has been captured in the example above. This moment was captured at 1/250 second. Since the background was misty, there was no real concern for depth of field. I also framed on a diagonal and allowed for the direction of the boat's motion into the left portion, making sure to include the ripples from the previous strokes of the sculls, all of which reinforced the forward motion.

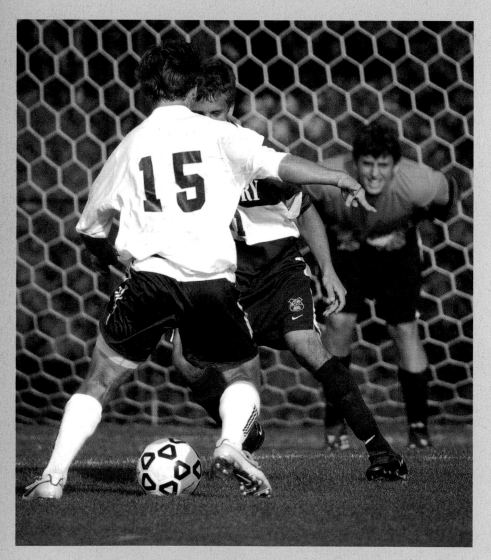

In the photo to the left, all three players have been caught in a dynamic pause. In the case of the attacker, he has just finished faking to the left before coming back to drive to his right. The defender (who did not go with the fake) is waiting for the attacker's next move, while the goalie (just out of focus) is crouched and ready to spring in the direction of the kick. I used a 400mm lens set at

1/750 second and f/5.6 from a position downfield near the opposite goal. Notice the concentration in the eyes of the defender just visible over the shoulder of the attacking player.

I also like to capture dramatic pauses when there is a high degree of tension, as in the situation of the pitcher stretching to hold the potential base stealer (right). Despite the fact that the main action in baseball occurs between the pitcher and the batter, I always look for secondary confrontations such as this, where the conflict between the pitcher and base runner is almost palpable. The runner looks ready to go as the pitcher decides whether to try a pickoff throw. Since I wanted the viewer's eye to go to the runner first, I focused on him and used a relatively shallow depth of field (f/6.7) to keep the pitcher in soft focus.

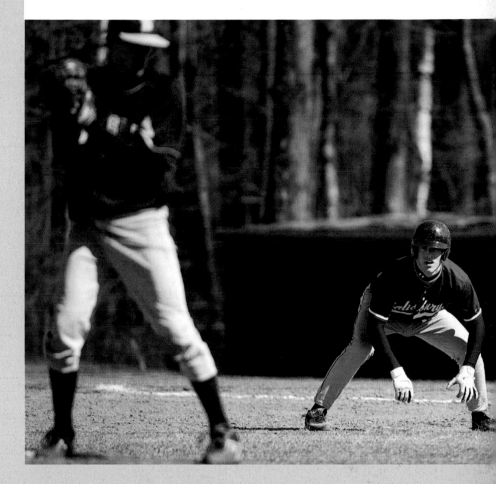

Looking for the secondary moments in action situations can sometimes pay off with an interesting composition, though it does require a certain amount of discipline to ignore the main action and look elsewhere. That is what happened in the basketball shot to the right, where I opted to photograph the expressions of the spectators just before they reacted to the ball going through the hoop. I thought about having both the players and the rows of spectators in focus, but the limited lighting forced me to use a f/2.8 setting for a 1/200 second shutter speed at 1000 ISO.

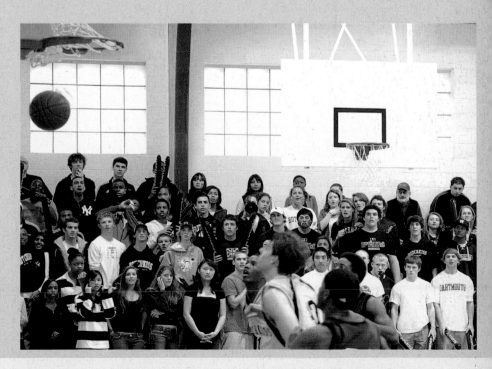

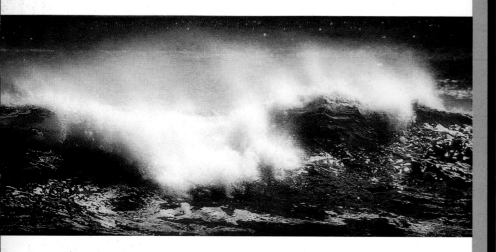

Photographing the Wind

How do you convey the impression of an invisible force such as wind? The answer is to rely on visual cues that will convey a sense of movement in a scene. As an example, note how the spray is blowing off the top of a wave in the photo above, which was shot at 1/100 second with a 300mm lens. Another common clue is the different body language that people use to adapt to various situations. Once again, you have to be sensitive to the opportunities that present themselves and think in terms of the photographic language of motion and time.

© Len Hellerman

Sometimes software can give the impression of the wind's effect as seen in the examples shown to the left. The upper frame was captured in a still moment. I then applied a #4 Tiffen Soft FX filter in the Tiffen Dfx software program that produced a motion-like blur seen in the lower frame.

The leaning postures of the people (opposite top and middle) clearly give the impression of them bracing against a very strong wind. In the bottom photo on the opposite page, the billowing sheets of diffusion cloth in a tobacco field convey the effects of wind on light fabric, while in the picture of the ocean horizon (right), the differences in the light as the scene grows darker from left to right, plus the expanse of the clouds slanting diagonally in the same direction, give the impression of a moving storm.

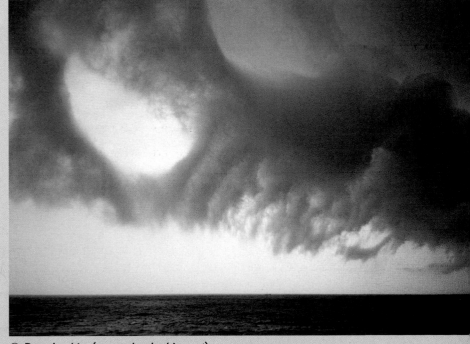

© Dan Larkin (www.danlarkin.net)

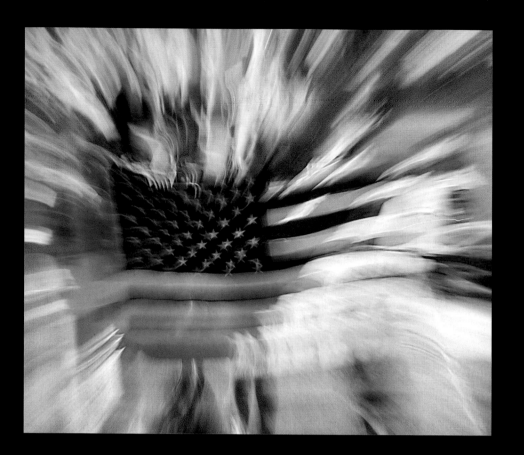

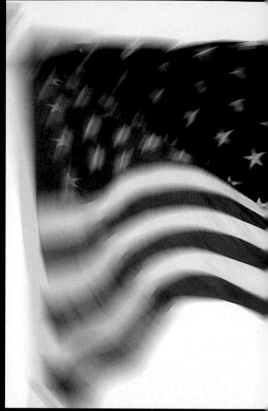

Abstractions of Motion

One of the most extreme effects of a slow shutter speed is the transformation of a moving subject into an abstraction. Methods for producing such results are covered in more detail in Chapter 5. Compositionally speaking, the key to an effective abstraction is to use subjects that are still recognizable after the abstraction has been applied.

Note that the primary features of the stars and stripes of an American flag are preserved to a recognizable degree in the series above, while the abstraction treatments still convey a sense of movement. The photo on the left was produced using a 1/2-second shutter speed while zooming in on a flag held at waist level by a group of children in a Memorial Day parade. In the middle pic-

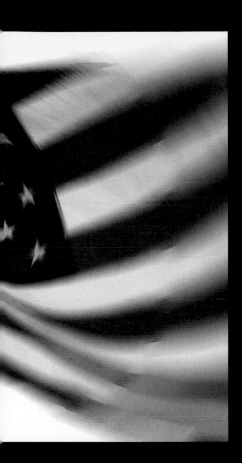

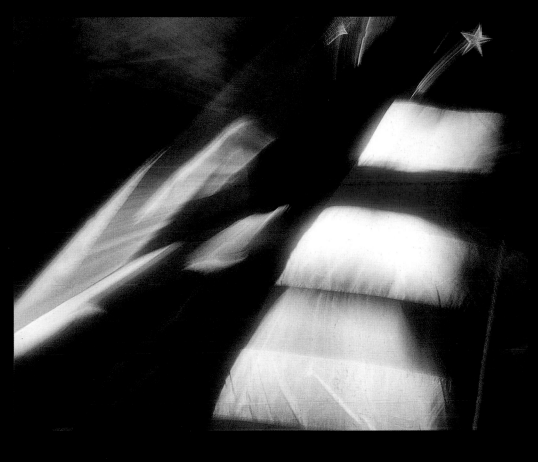

ture, the original image of a sharply focused flag was given two spin filter treatments in Adobe Photoshop (Filter> Blur> Radial> Spin). The third photograph, on the right, was the result of moving the camera in and out quickly at arms length using a shutter speed of 1/4 second with the flag set against a black background. These forms of "free styling" with the camera, first mentioned in Chapter 1, are covered further in Chapter 5.

We now have a solid base of compositional devices with which to capture various types of situations where motion and the passage of time are playing a critical role. Let's use the next chapter to consider some of the setting options to help get the camera optimized for producing the effects you want when recording motion.

3 Optimizing Camera Functions

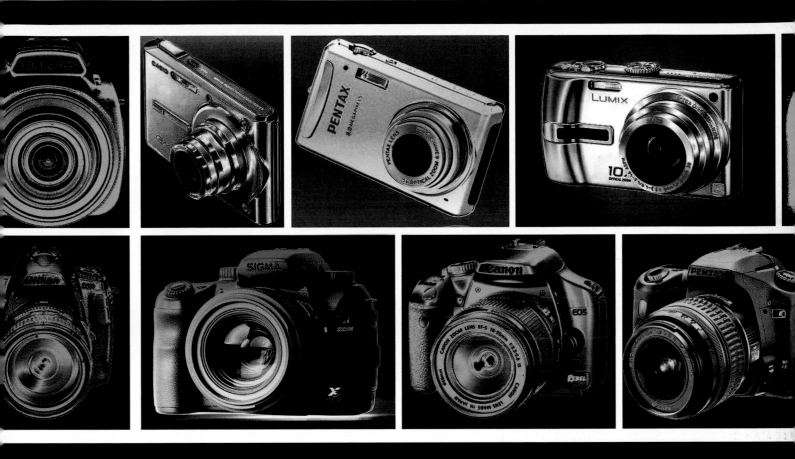

The successful interpretation of time and motion in still photography is best carried out with a camera that has been optimized for these purposes. Demand on camera performance is higher than normal when trying to freeze a fast moving subject; and even when using slow shutter speeds, key camera functions should be set to obtain the best possible results. Just how these functions should be arranged will depend on the particular situation, including the type of subject, the specific movement involved, and the characteristics of the light in the scene. In the case of a sporting event, the action is occurring continuously, so you can enhance effectiveness by taking pictures in bursts using the camera's drive mode settings, which is a different situation than trying to photograph an actor's facial expression on a poorly illuminated stage, where just one shot and good timing are required.

In situations where slow shutter speeds are used, you must hold the camera very still or move it to follow a moving subject. A sturdy tripod with the appropriate head is recommended when you find yourself in such situations. In addition, the intensity and quality of available light will have an effect on your photography: Is the camera set to deal with changes in light levels or with different color temperatures, for instance when the subject moves from sun to shade?

Since there is such a diversity of need when it comes to properly setting your camera, let's look at the functions and features that are important to all forms of motion photography.

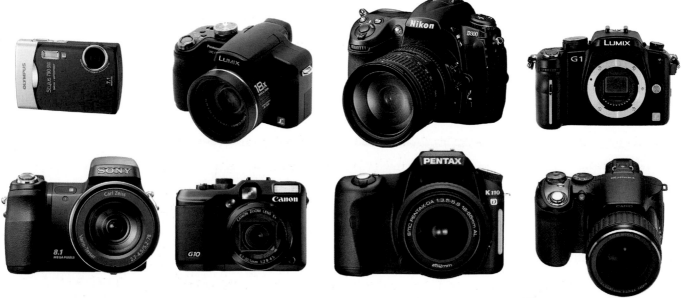

Digital cameras are available in a wide assortment of types and styles, from small point-and-shoot kinds (upper left) to more complex fixed-lens compact models (such as the Canon G10, bottom row, second from left) to high-performance D-SLRs (like the Nikon D300, top row third from left) with immediate shutter response and interchangeable lenses.

Digital Camera Styles

Today's digital marketplace offers a number of different camera designs, from simple point-and-shoot models to highly sophisticated, interchangeable-lens digital single-lens-reflex (D-SLR) cameras. The technical demands of photographing motion, especially fast action, place a premium on cameras that operate quickly and accurately. After all, regardless of the situation, the camera should respond to your commands as rapidly as possible so you can capture what you see when you see it. In general, D-SLR cameras operate the fastest and are the primary choice for professionals such as sports photographers, wildlife photographers, and photojournalists, who make their living dealing with action situations. Consequently, the emphasis will be on these models throughout the book.

A second choice for recording action would be those cameras often referred to as advanced compact digital cameras. These models have fixed zoom lenses and are just below interchangeable-lens D-SLRs in range of functions and features.

The last choice would come from a variety of smaller point-and-shoot models that often have disadvantages for the action photographer, such as a long time (up to a second or two) between shutter activation and recording. This shutter lag can result in missed shots when recording motion photos.

The D-SLR design has several key features in its favor. First of all, viewfinders in D-SLRs are generally the largest available and provide an accurate and intimate view of the subject. Note the comparison between a typical peephole viewfinder on a point-and-shoot camera (above, top) versus the significantly larger viewfinder eyepiece of a D-SLR (above, lower). No question about it; the larger D-SLR viewfinder certainly helps you concentrate on the action of the scene. In addition, the photographer is viewing the scene through the lens that will actually take the picture. This means any effects of decompression by a wide-angle lens or the compression of a telephoto lens will be

apparent. Also, D-SLR viewfinders, unlike other designs, show 90% or more of what will be recorded on the sensor. By comparison, the smaller eyepieces of non-D-SLR viewfinders encourage users to use the rear LCD to view the scene; some models don't even have viewfinders. Users will therefore hold the camera away from the eye and watch the subject on the LCD screen. Though it is possible to take action photos in this manner, the intimate quality of the D-SLR viewfinder is far more engaging. Plus, when the viewfinder is used, one tends to hold the camera in a better position to control camera shake, as opposed to having the arms held away from the body to see the LCD. Another major advantage to the D-SLR is the interchangeable lens capability that puts these cameras in a class by themselves.

One significant disadvantage of the D-SLR design is that the precise moment of capture is not seen through the viewfinder because the reflex mirror has flipped up to permit the light to reach the sensor. This blocks the view through the viewfinder for a split second and is the basis of the adage among digital SLR photographers: "If you see the moment of action you want in the viewfinder, you missed the shot!" So, users of D-SLR cameras learn to anticipate and press the shutter release button just before the action occurs.

Very recently, a new class of interchangeable lens cameras, such as those from Panasonic and Olympus, has come to market using the Micro Four-Thirds design. These cameras do not have reflex mirrors and are smaller than the typical D-SLR camera. They use a high quality video display in the viewfinder. Also, the Casio Corporation has released a video-based still frame camera that takes up to 60 frames per second (fps). It remains to be seen how these two new designs will impact the choices in action photography.

In addition to shutter lag and viewfinder technology, there are other factors that influence the speed with which you can record action, especially when taking a burst of pictures. Specifically, there is the choice of focus mode, the autofocus lag time, the burst rate, the size of the camera's buffer, and the write speed of the memory card. Let's take a look at the importance of these and other camera functions as they affect motion photography.

Pre-Setting Your Camera to Capture Motion

Step 1: Exposure Settings

There are four exposure modes on D-SLRs that are most important for motion photography: Aperture Priority (A), Shutter Priority (S), Manual (M) and Program (P). These are often selected using a Mode dial.

In Aperture Priority, the photographer selects the aperture (f/stop) and the camera's computer adjusts the shutter speed for a correct exposure. Shutter Priority reverses this by allowing the photographer to select the shutter speed and letting the camera adjust the aperture. Shutter Priority is usually the best selection for photography that requires a slow shutter speed. This mode lets you set an exact shutter speed that the will give the anticipated results. For example, photographing runners at 1/15 second produces the desired amount of blurred motion for moving arms and legs. The shutter speed will remain the same while the aperture changes to give the correct exposure. Using Shutter Priority is also a good way to approach a new situation. By dialing in specific shutter speeds, you can assess the outcome when reviewing the images on the camera's LCD screen to get a general idea of the results.

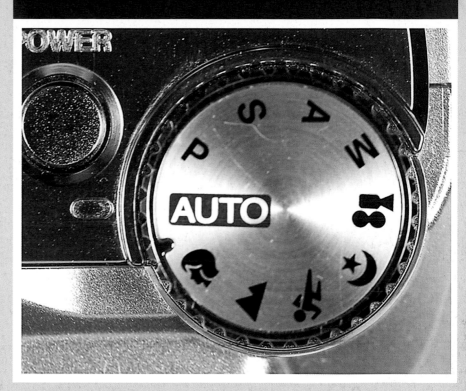

A camera's Mode dial permits you to make settings on your camera that control the way you can portray motion, whether stopping the action of your subject or isolating it against a blurred background.

In cases where a fast shutter speed is required, the deciding factor for choosing an exposure mode (in addition to how fast the subject is moving) is often determined by how much depth of field is needed. For example, if the goal is to isolate the subject from the background, then a wide aperture opening with limited depth of field will work best, which you can control using Aperture Priority. On the other hand, if depth of field is not an issue, then Shutter Priority will assure the same motion-freezing effect from picture to picture.

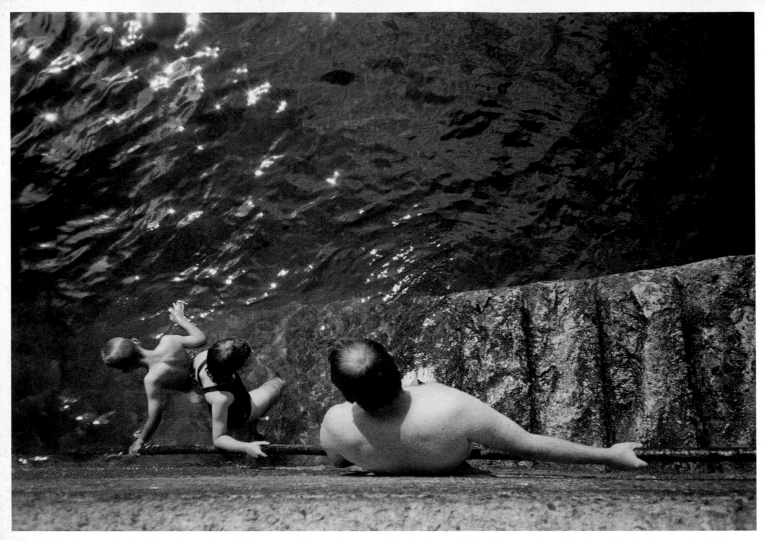

Manual exposure mode allows you the ability to control aperture and shutter speed simultaneously, giving you the best opportunity to balance the need for both depth of field and rendition of motion. © Dan Larkin (danlarkin.net)

When using Manual exposure mode, the photographer fully controls both the aperture and shutter speed settings. Such total control gives you a number of creative options for exposure, but may present problems in situations where the light is changing and you don't have time to alter the settings. In the days before cameras had autofocus and autoexposure modes, all action shots were done manually. I remember those days fondly, but do not want to return to them for one important reason: Today's digital cameras operate so much faster that they allow me to capture many more pictures that are correctly exposed and in focus for any given action situation.

In Program mode, the camera sets both shutter speed and aperture based on information programmed into the camera by the manufacturer. This is the least desirable choice for motion photographers, since there is no direct control of shutter speed. A number of cameras also offer a variety of exposure modes in the form of categories, such as Sports or Landscape settings. These are basically a form of the Program mode

meant to accommodate a specific type of subject. For example, there is an emphasis on greater depth of field in the Landscape mode, and a bias to fast shutter speeds in Sports mode. But for the motion photographer who seeks to control each situation in order to achieve a certain result, this is not a good approach. For example, though a shutter speed of 1/250 second would yield the desired effect for a given situation, the Sports mode may or may not use that setting—it is up to the camera's computer and how it has been programmed. The bottom line is that the Program mode and its variations take control of key settings out of the hands of the photographer.

If you plan to record using burst rates with a high number of frames per second, keep in mind that the selected shutter speed must be fast enough to handle a high-speed rate. This may not be a problem under normal circumstances, since a fast shutter speed is usually employed when trying to freeze motion. But when using a slow shutter speed, the camera's burst rate may be slowed by virtue of the time required by the extended shutter speeds. In this case, it may be best to switch to taking single-frame exposures.

The color of light, or its "temperature," is different depending on its source. With built-in white balance (WB) settings, digital cameras have the ability to adjust to these variations in the color qualities of light. But if the white balance is set improperly, your pictures will have a color cast. You will want to notice whether a subject in motion is moving from one light source to another.

Some of the most common sources of light include the sun, household incandescent light bulbs, fluorescent tubes, electronic flash, and forms of studio tungsten light. When red, green, and blue wavelengths of light are equal, each at approximately 33% of the total, the light source is considered color-neutral and is referred to as "white light." So, if a pure white wall were photographed with a camera balanced for white light, it would appear as white. Mid day sunlight and electronic flash have approximately equal amounts of red, green, and blue wavelengths, so these sources are considered neutral. On the other hand, cloudy daylight and shade areas will have proportionally more blue and less red, while sunrise and sunset—as well as tungsten lighting—will have more red and less blue. Green tends to remain at about 30% in all these situations. Consequently, if the white wall is photographed on a cloudy day or in the shade, it will take on a blue or cool cast. If it is recorded during a sunrise or at sunset, or with a tungsten source, the wall will have a red or warm cast.

The color temperature of light, the degree of its warmth or coolness, is measured on the Kelvin scale (K), where the temperature range of 5400 – 6000 K is considered neutral for most photography. The lower the Kelvin temperature, the warmer the light; and the higher the temperature the cooler the light. Certain man-made sources, such as mercury vapor and sodium vapor lights, lack significant amounts of some wavelengths and are characterized by a strong colorcast (yellow in the case of mercury vapor lamps and orange-yellow with sodium vapor lamps). In addition, overhead commercial fluorescent tubes will have a strong green cast.

In addition to providing choices in white balance settings that help you neutralize the color of the light source, some cameras will allow you to dial in a specific Kelvin tem-

Figure 1: Approximate Kelvin Scale and Percent of RGB Wavelengths

Light Source	Kelvin Temperature	(Red)	(Green)	(Blue)
Sun*/Strobe	5400 – 6000K	33%	33%	33%
Tungsten (Studio)	3200 – 3400K	50%	30%	20%
Tungsten (House)	2500 – 3000K	61%	32%	7%
Overcast	6000 – 8000K	27%	34%	39%
Blue Sky	10000 – 15000K	17%	34%	49%

* From approximately four hours after sunrise to approximately four hours before sunset.

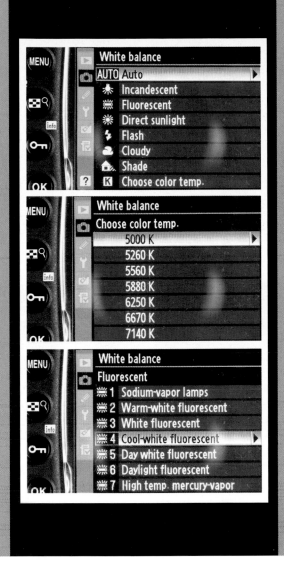

perature or even modify a particular white balance choice, such as the variations in fluorescent setting as seen in menu illustration to the left. Just how much the white balance setting can change the way colors in a scene are recorded can be seen in the examples shown in in the series of photos below. Frame (a) is a color-balanced scene of white and gray tones captured on a sunny day with the camera set for direct sunlight (usually denoted as a Sun icon). The remaining frames give the idea of the direction in which the colors can shift when the same sunny scene is photographed with the camera set on (b) cloudy (c) shade (d) tungsten, and (e) fluorescent. The warm colorcasts seen in frames (b) and (c) result because the camera is being told the scene is cool (cloudy and shade settings)—so the WB setting compensates by correcting with complementary colors that offset the excessive blue characteristics of cool color temperatures. On the other hand, the cool cast in (d) is an offset for the increase in warm wavelengths found in a tungsten source. The magenta cast in frame (e) is the complementary color to the green cast of fluorescent lighting.

The selection of a particular white balance setting is a choice you make depending on how you want the color to be rendered. Very often, Auto White Balance (AUTO or AWB), which is determined by the camera, is the most useful for action situations where the qualities of light can change as the subject moves about.

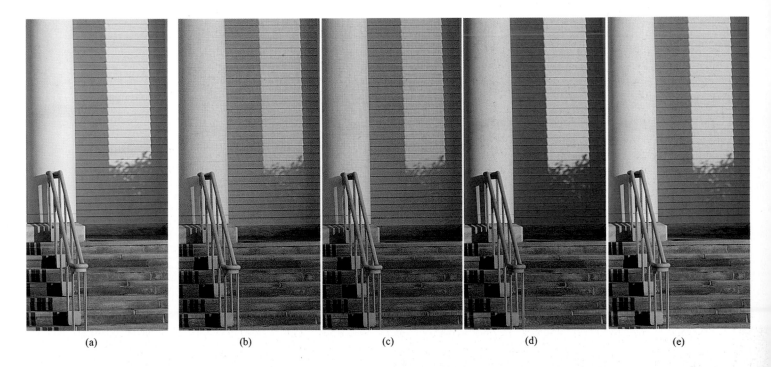

(a) (b) (c) (d) (e)

Once the exposure and white balance modes are set, the next consideration is to get the subject in focus. D-SLR cameras will generally have a choice of at least three focusing modes: Single autofocus (S), Continuous autofocus (C), and Manual focus (MF). The focus mode settings might be found on the camera's body (left), or perhaps within the camera's menu system. The active area of a scene on which the lens will focus is usually indicated in the viewfinder by a target such as a set of brackets, a small box, or a circle. In the case of Single autofocus, pressing the shutter release button only halfway will cause the lens to focus on the target area without taking the picture. As long as the button is held in this position, the focus will not change. Pressing the shutter release all the way will record the picture.

Single autofocus is not a good choice when shooting a moving subject since you will have to release the button and then refocus as the subject-to-camera distance changes. The Continuous autofocusing mode is a better choice. It is also activated by pressing the shutter release button halfway, but the camera will continuously adjust to a moving subject provided the button remains slightly depressed and the focus target in the viewfinder is kept on the subject.

The third choice, Manual focus, is used far less these days than was the case years ago, mainly because autofocus has become so fast and accurate.

Back when film was king, Manual-focus SLRs typically had focusing screens with some sort of visual aid such as a split screen or micro prism that indicate when the lens was in exact focus. Digital cameras rarely have these aids, making it more difficult to determine visually when you are in exact focus. To help indicate when precise sharpness is achieved, digital cameras often have an indicator in the viewfinder such as a colored dot that will light when the camera is in focus. This is certainly helpful, but most action photographers have come to depend on the autofocus function of their D-SLRs.

In either Single or Continuous focusing modes, the time it takes for a lens to lock on to a subject is considered the autofocus lag time. For some cameras, especially compact point-and-shoot models, this can approach a full second. That is an eternity in motion photography and means there will be a lot of missed shots. Also, when focusing in dim light, the autofocus function may not work effectively. The best choice is a camera that has a short autofocus lag time. As a general rule, D-SLRs and the high-end digital rangefinder cameras, such as those made by Leica, have the fastest focusing speeds.

Moreover, their sophisticated focusing systems are extremely accurate in targeting a subject. Pro level cameras are, hands down, the best at quickly locking and maintaining focus with fast moving subjects. Having said that, even the most inexpensive D-SLRs are becoming quite fast at focusing and can certainly handle most action situations better than point-and-shoot models.

Step 4: Shutter Lag

With the camera's exposure mode set on either Aperture Priority or Shutter Priority, its white balance set to AWB, and the lens focused on the subject in Continuous autofocus, next consider the speed with which the camera responds to your command to take the picture. This shutter lag, the time between pressing the shutter button fully and capturing the picture, is crucial to the action photographer. The ideal camera for any form of motion photography is, of course, one that has a very short shutter lag time. There is nothing more frustrating than missing a shot because of a time delay after pressing the shutter release, when the camera does not respond immediately to take the picture.

While there has been a general reduction in lag times with all of the latest digital cameras, it remains a significant drawback of most non D-SLR models, especially the small, less expensive ones. Furthermore, when working in dim light, the lag time is likely to increase. As a generalization, today's D-SLRs and top-of-the-line digital rangefinder cameras, plus some of the more advanced fixed-lens digital zoom cameras, will have short shutter lag times, so they are fast enough for most situations. It is absolutely critical to be able to take the picture at the time you want for both fast and slow shutter speed motion photography.

The lag between command and capture is due to the complex way that digital cameras record images. With film, once the shutter is opened, the light strikes the chemicals on the film's surface and causes a latent image to form. The film will then be chemically processed later to produce a visible image. In the case of a digital camera, the image will be processed and stored on a memory card and can then be viewed on the LCD screen within a matter of seconds. However, to accomplish this, a number of electronic processes have to occur in a very short period of time. For example, in the case of a CCD (Charged Coupled Device) sensor, this electronic receptor has to take on a charge before being exposed to light to record the image. The changes in this signal produced by the light have to be drained off the sen-

sor, processed by the camera's computer, downloaded to a memory card, and then the sensor must recharge for the next exposure. This takes time, hence, the dreaded shutter lag.

Step 5: Burst Rate, Buffer Capacity, and Memory Cards

Having a short lag time between command and capture is only the first critical factor when shooting several continuous frames at a fast shutter speed. There are three other things to consider: The burst rate of the camera, the size of the camera's buffer, and the speed of the memory card. These three functions play a role in all image recording, but become more critical as the burst rate increases.

The burst rate of a camera refers to the number of frames the camera can take in one second (frames per second: fps) when the shutter release button is held down. This is also often referred to as continuous shooting or continuous drive. Typically, D-SLRs have two choices for shooting continuously, usually designated as low and high. There is also the option of single framing: Taking one frame with each complete press of the shutter button. Thus, depending on your particular camera model, pressing and holding the shutter button in continuous drive mode may result, for example, in 3 fps

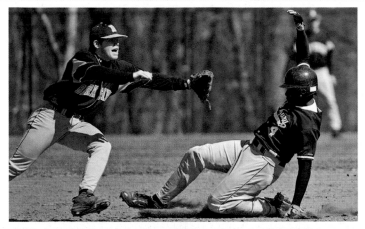
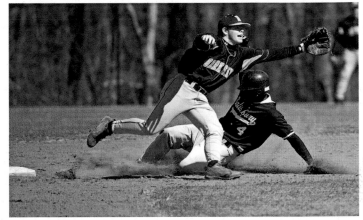
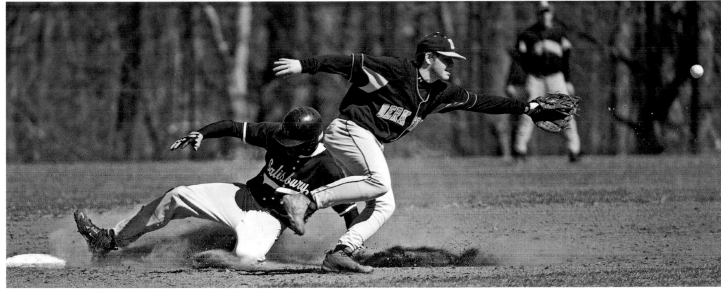

at the low setting and 6 fps at the high setting. The top professional D-SLR models have high-speed rates as fast as 10 or 11 fps.

The baseball sequence above illustrates the advantage of using a fast burst rate. I had intended to just photograph the slide of a player coming into third base. Instead, the third baseman had to deal with a poorly thrown ball, so I kept my finger on the shutter release, recording 6 fps at f/3.5 and 1/1000 second. Any of these three pictures could represent a play at third, but it is only the last frame that shows the runner safely

sliding into third with the defender moving out of position to catch the ball that now appears in the frame. The three critical compositional components that tell the complete story—the moving defender, the sliding baserunner, and the errant ball—did not appear until the last frame.

Many action photographers take full advantage of high burst rates (and large buffer capacity) to shoot continuously as soon as the action begins, all the while following the full sequence of activity. In this way, they are assured not to miss anything. Others

may concentrate on only those segments of action that they think will contain the winning shots, using shorter bursts and lower fps rates. And still other photographers will take only one or two shots with single framing. Which approach to use is up to the individual photographer, and the next chapter has information about how to approach fast changing situations. But it is worth pointing out that some of the greatest action photographs taken over the last 80 years were done without a continuous drive camera. For example, virtually all the famous pictures taken of the legendary Babe Ruth swinging his bat, and of boxing champion Joe Louis fighting in the ring, were done with a single-shot 4x5 Speed Graflex camera. The point is, camera speed can take you just so far. In the end it comes down to recognizing opportunities and developing a sense of anticipation about when to take the picture.

Once the picture has been taken, the image information coming from the sensor goes to the camera's buffer, where it is written to the camera's memory card (most commonly in either the JPEG and/or RAW file formats—some cameras offer TIFF recording, but that is increasingly rare). All camera buffers have limits as to how much information they can hold. Once filled, the camera will not take any more pictures until room is made in the buffer as information is written to the memory card. The larger the size of the file being captured, the fewer the

number of exposures can be held in the buffer. For example, assume a hypothetical camera set to record JPEG files at 3MB can handle up to 30 frames continuously before the buffer fills. If the camera is set to capture larger RAW files with a recorded size of 9MB, then the buffer can only handle 10 image files. Consequently, a camera's fps burst rate is controlled by the high and low fps speeds of the camera, while the buffer defines the maximum number of frames that can be taken continuously.

Unlike JPEG, RAW files capture a scene without significant in-camera processing. JPEG and TIFF files, on the other hand, are processed in the camera's computer. Thus, a major advantage of the RAW file is that you can work with the original image data to make corrections in the computer for exposure, color balance, contrast, and many other parameters. In addition, the camera's metadata is brought up in the processing software, which allows you to see the camera settings that were used for the picture. Metadata is commonly saved in an EXIF (Exchangeable Image Format) segment within the file and can be read by various imaging software programs. This information can help you determine what settings worked well and what settings did not.

The down side of RAW is that each camera model uses a proprietary form of this format. Thus, you must have the specific software that will process your particular RAW format. As each new camera model comes out, new software updates for those models have to be added. The camera manufacturer supplies this software only for their models. A number of software companies, however, offer RAW format processing for a wide range of camera models. The most popular are Adobe's Photoshop CS, Lightroom, and Photoshop Elements image processing programs. The enormous control over each image that RAW processing provides is illustrated in the illustrations above. The top frame shows the main dialogue box of the Adobe RAW file processing program found in Photoshop. The bottom row contains five more control menus that can be accessed within this program to refine the image before saving it as a JPEG, TIFF, or PSD (Photoshop) file.

Next, consider the speed of the camera's memory card. A memory card is basically a small removable storage device that uses either solid-state flash memory or micro drive. Micro drives are less common and have slower recording speeds due to the moving parts of their technology, while the vast majority of cards on the market now use solid-state technology. These cards come in several configurations, including Secure Digital (SD), Secure Digital High Capacity (SDHC), and CompactFlash (CF). The key performance specification for a motion photographer is how fast the card records images from the camera's buffer (write speed). The larger the size of the file to be recorded, the longer the write time. While the card is writing data, an indicator light on the camera body illuminates and stays on until the data is recorded. During this period, it is good practice not to preview the image on the camera's LCD screen. If you are going to be photographing at high burst rates with long sequences, it is important to use memory cards with fast write speeds. In recent years, these speeds have increased significantly so that the fastest cards should not be a limiting problem. Card manufacturers denote write times in MB/second. You can check the results of independent testing on the Web, where one of the most complete listings for Canon and Nikon cameras is Rob Galbraith's popular professional site, www.robgalbraith.com.

Shutter Speed, Aperture, and ISO

In addition to shutter speed, the demands of obtaining an appropriate exposure and depth of field require that attention must also be paid to the aperture setting and the ISO sensitivity when recording motion. Thus, any decision about shutter speed has to consider aperture and ISO values.

Shutter speed, aperture, and ISO affect each other according to a relationship based on proportional changes. Doubling or halving the value for shutter speed, aperture, or ISO produces the same proportional change in the amount of light. Specifically, if the aperture is opened by one full stop, such as from f/11 to f/8, the amount of light allowed into the camera is doubled. Conversely, closing down the lens by one full stop, for example from f/11 to f/16, cuts the total amount of light allowed by half. In the same way, slowing the shutter speed by a full stop (for example from 1/60 to 1/30 second) doubles the amount of light entering the camera. And if you double the shutter speed, you will decrease the amount of light by one half.

The ISO setting represents the sensitivity of the camera's sensor to light. The higher the ISO number, the greater the sensitivity. If the ISO setting is doubled (from ISO 200 to ISO 400, for example), the sensor becomes more sensitive to light by the equivalent of one stop (which is the same as opening the lens by one stop or decreasing the shutter

speed by one half). Lowering the ISO number decreases the sensitivity to light in the same relationships. Thus, decreasing the value from ISO 200 to ISO 100 results in the loss of one full stop of light.

Why bother with all this? Because it allows you to quickly determine the limitations for a particular situation. If you know a single combination of aperture, shutter speed, and ISO settings for the correct exposure of a particular scene, you can then quickly figure other combinations within the available light that allow you to increase or decrease the shutter speed as needed, or, for that matter, let you set an aperture to increase or decrease the depth of field with a specific shutter speed.

Shutter speed has a major effect on how motion will be rendered, but it does not exist in a vacuum. The relationship between shutter speed, aperture, and ISO is extremely important. © Dan Larkin (www.danlarkin.net)

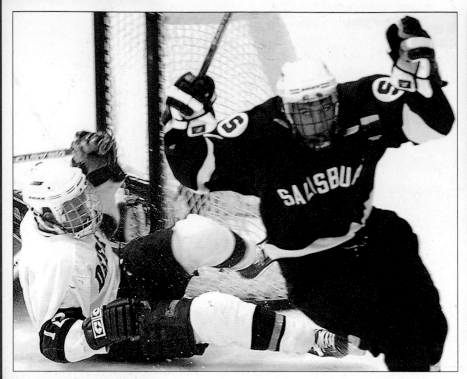

Noise

Digital image recordings contain a variety of non image-forming signals collectively known as noise. Typically, these unwanted artifacts take the form of white or randomly colored speckles. They can also occur as areas of colored blotches or band-like irregularities. These signals are most noticeable in smooth, evenly colored sections of a picture, especially the darker portions.

Certain shooting conditions in motion photography can increase the visual prominence of noise; in particular, setting high ISOs in order to use fast shutter speeds to freeze action. High ISO settings amplify the image-forming signal, and that also amplifies the appearance of noise as illustrated in the photo above, taken at ISO 3200. As a

generalization, noise becomes a problem at ISO 1600 or above with D-SLRs, and above ISO 400 with point-and-shoot models. D-SLR cameras perform better because they have comparatively larger light-collecting photosites on their sensors, resulting in a lower proportion of recorded noise signals. Another typically "noisy" condition occurs when long exposures are used to produce blurred motion effects. Long exposures measured in seconds tend to generate higher levels of heat at the sensor, leading to a condition known as thermal noise.

Higher noise levels also tend to occur when photos are underexposed, because photographers become overly cautious in trying to safely preserve all-important highlight

Features and Accessories for Motion Photography

detail. They will expose their image so that highlight areas fall short of the right axis on the recording's histogram, making underexposure more probable. The result is a reduction in the amount of the image-forming light for shadows and darker areas, and thus a more prominent level of recorded noise. One strategy to avoid this is to "expose to the right." This involves setting the exposure so that the highlights with details on the camera's histogram are as close as possible to the right without clipping. This often results in a slightly overexposed scene, but with lower levels of recorded noise in shadow and middle tone areas. This slight overexposure can then be corrected in the computer.

There are also other approaches. For example, many D-SLRs have noise-reduction settings for use with long exposures. And then there are specialized noise-filtering programs that can be applied when processing the image file on the computer. Some of the most popular programs among photographers include Neat Image by Neat Image, Picture Code's Noise Ninja, Nik Software's Define, and Imagenomic's Noiseware.

One feature found in today's lenses that is very useful for motion photogrpahy is image stabilization (known by various names from different camera manufacturers—also found in some camera bodies). Though the manufacturers claim this technology offers the ability to handhold a camera at slow shutter speeds by greatly reducing the effects of camera shake, I have found that results vary from lens to lens. However, when using the best of these image-stabilized lenses, you can usually handhold the camera one to two shutter speeds slower than without it. In the end, photographers have to test their own lenses to determine how much they can lower their handheld speed. I usually turn off any image stabilization lens function when using a tripod.

There are a number of accessories used by motion photographers that are worth noting. A sturdy tripod is a must when using a slow shutter speed. In addition, the tripod head should be capable of panning the camera in a reasonably smooth fashion. This makes it easier to follow a moving subject while using a slow shutter speed to blur the background, yet still render the subject reasonably sharp. (This pan blur technique is

covered in Chapter 5). Most lever and ballhead models will have this horizontal panning action. I prefer ballheads since they make it a bit easier to follow a subject horizontally as well as adjusting to any vertical deviations.

A possible alternative to the tripod when recording pictures with a slow shutter speed is the use of a beanbag. These can be very handy, especially when you don't have your tripod with you. Beanbags (left) are also a great way to deal with situations where no tripod is allowed. They can be set on a railing, banister, car fender, etc., often allowing you to take the picture quickly in an unobtrusive way. And don't forget about mini-tripods, sometimes called tabletop tripods, that can be set on a table or against a wall for long exposures.

For fast shutter-speed work with subjects moving in many different directions, the monopod is a popular choice, especially among sports photographers. It has at least two advantages. First, it holds the weight of the camera and lens, eliminating shoulder and arm fatigue that can set in over the span of photographing several hours. In this regard, if you are using a heavy lens, the monopod is really a must. Second, in comparison to using a tripod, it becomes easier to change camera position quickly.

In the past few years a number of hanging cradle heads have become popular with many nature and sport photographers. These can be used on either a tripod or monopod. They provide a solid base to hold the camera, but also offer maximum flexibility and smooth action for following a fast moving subject. Examples include the King Cobra from Kirk Enterprises and the GB Gimbal roller bearing design from Custom Brackets (left). Meanwhile, nature photographers, especially those photographing birds, have found various shoulder stock arrangements an advantage for holding the camera steady as well as for easier tracking (see the BushHawk BH-320D-T, opposite, above).

There are often times when there is too much light to set the camera speed slow enough to produce the type of blurred action effect that you might want. The classic example is a stream or waterfall on a bright overcast day. As a remedy, consider a neutral density (ND) camera filter, which

has only one function: To reduce the total amount of light entering the camera without directly affecting color or contrast. This type of filter comes in either a round configuration that screws on to the front of the lens, or as a square/rectangular model that drops into a holding bracket attached to the front of the lens. The strength of the filter is determined by the amount of light blocked, as indicated in Figure 2. Recently, the Singh-Ray Corporation has made available a unique version of the neutral density design called the Vari-ND Filter. It has a ring rotation mechanism that allows the user to continuously dial in from 2 to 8 stops of light blockage. This allows you to set the shutter speed exactly where you want just by rotating the outer ring of the filter.

In summary, the ideal camera to capture time and motion is one that responds fast and accurately to your commands. This is especially critical when using fast shutter speeds and high burst rates for the type of action found in wildlife and sports photography. Shutter Priority will insure a shutter speed appropriate to the situation. If depth of field is critical, then Aperture Priority is often a better selection. Continuous autofocus and Auto White Balance are the best choices, along with a memory card with a fast write speed. Other critical functions include the virtual non-existence of autofocus and shutter lag times, a high burst rate, and a large camera buffer capacity. D-SLRs are the best over-all choice. The requirements are less stringent for slow shutter-speed photography, but short shutter lag

and quick autofocus times are still critical. Now let's consider the dynamics of fast shutter-speed photography with moderate to fast moving subjects.

Figure 2: Neutral Density Filter Factors

Filter Factor	ND Rating	Light Loss (in Stops)
2	0.3	-1
4	0.6	-2
8	0.9	-3

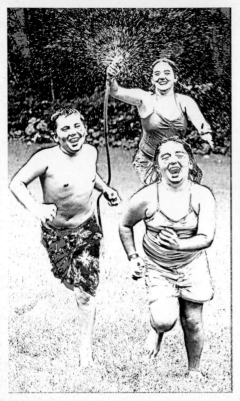

4 Fast-Action Photography

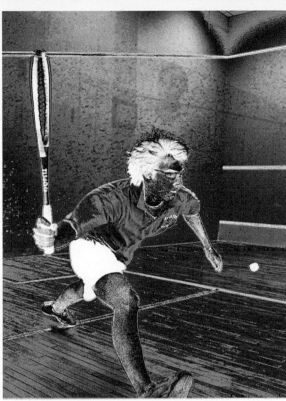
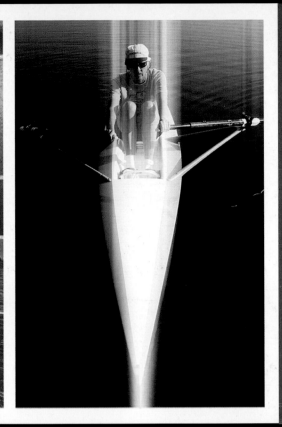

Working at sporting events and teaching at workshops over the years, I have noticed that many photographers handle fast-action situations by blasting away with their cameras—at one time with their film motor drives, and now with their digital continuous shooting modes—hoping to catch a winning image of their subject (sort of a "spray and pray" approach). Indeed, successful action photography using fast shutter speeds does require quick camera skills. But as anyone who makes a living in this sort of work knows, there is far more to the process. Fast firing must be combined with a concept of the motion involved and an ability to anticipate when there is potential for a great picture. This chapter is about optimizing the conditions for getting outstanding results using fast shutter speeds. Much of this information is also applied in Chapter 6 regarding sports photography.

Developing an Action Mind Set

Human vision is limited when it comes to seeing specific segments of a fast movement. Even if you can see the ideal moment, it may happen so quickly that you aren't able to react fast enough with your camera. Compare this to a portrait or landscape setting where there is time to contemplate the best moment for taking the picture. We tend to perceive fast movements as a continuum—a whole motion in which we can clearly recall the beginning and the end. But because the bulk of the action in between happens so fast, we have trouble isolating individual segments. Such descriptive phrases as "the player made a great move," or "the dancer performed a beautiful motion" are used to sum up the whole movement because we cannot see the separate, individual portions. Thus, we are often left with a general impression of an entire movement. It is a skilled motion photographer who delves into this middle ground to recognize a great moment, and records it as a single representative image. But how does one develop such a skill?

One of the first steps to successful fast-action photography is to put aside the tendency to think of action as a whole and think instead in terms of single segments. The analogy of a single slice of bread out of the whole loaf comes to mind. But unlike the uniform slices in a loaf, the segments of a whole movement show great variation (as Eadweard Muybridge documented for the first time so long ago, see page 28). Some segments can appear dramatic and some will look awkward—and still others rather ordinary, if not boring. Modern commercials, music videos, and other examples of today's quick-cut visual media have built their dynamic appeal on selecting and presenting the most desirable moments to the viewer. The result is the reduction of a motion into quick flashes of individual components seen for a fleeting moment, rather than a presentation of the entire motion from start to finish.

The challenge for any photographer is to catch that one segment of motion that embodies the whole movement: The dancer at the apex of a beautiful leap, the football player at the moment of catching the ball in a pack of defenders, or the maximum height of a wave about to crash on the shore. The variable that makes it difficult to capture such moments is, of course, the speed of the event. Consider the example of a person casually walking or a couple dancing to a slow song. With a little concentration, it is relatively easy for the photographer to single out and capture a position that is complimentary to the subject and representative

of what it is doing. This is because we can usually see the specific portion of movement we want. But once the action quickens and the person starts running, or a couple begins dancing fast, it is far more difficult to see and capture that desirable position. Let's look at some successful examples of capturing a single section of a movement that summarizes the action in question

While visiting Bosque del Apache National Wildlife Refuge in Socorro, NM, I saw a composition beginning to develop as wildlife photographers with their long telephotos were set up in front of an approaching flock of geese (below). The sun had just come over the horizon and the photographers were concentrating on waterfowl in the ponds to the right outside the frame. As the geese approached, I wanted to have the them overhead as background, with the

photographers concentrating on their own quarry and not looking at me. With my zoom lens set toward the wide end at f/8 from a slightly lower then eye-level perspective, I used ISO 800 and a shutter speed of 1/500 second to freeze the wings of the birds. I feel this is a successful picture because it captures the wildlife photographers at work against a background containing their subjects. The key was to freeze the geese at just the right moment overhead. Notice also that the photographers were captured very close to the rule of thirds vertical power points.

The wildlife example with the geese reminds us that not every action shot has to contain large-scale dramatic movements (such as a roaring waterfall or a great play in a football game). Rather it is often small but important pieces in a picture that will make the difference. For instance, take a look at the image to the right by photographer Dan Larkin. It simply shows people walking in Amsterdam, but a number of photographic elements give it a sense of action and purpose: The wide perspective showing many people coming and going all at once; the juxtaposition of the moving walkers and the stationary bicycles; and the sun low in the sky casting long shadows that lend direction and momentum to the people, plus a sense of time as the walkers briskly go about their late afternoon business.

© Dan Larkin (www.danlarkin.net)

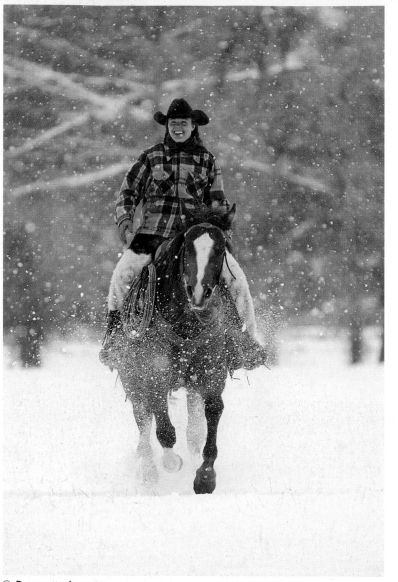

© Donnette Largay

small particles at 1/800 second. This shutter speed also renders the falling snow as flakes instead of nearly invisible streaks (see page 17). This is a photograph in which a specific shutter speed and timing by the photographer combine to capture one moment of a scene. Notice also how Largay's choice of an f/4 aperture produced a shallow depth of field that nicely isolates the subject from a busy background.

Largay's second photograph, of the cowboy chasing a mustang, records a specific moment when the lasso is over the head of the rider, about to be thrown to capture the escaping horse. Her experienced eye has also captured the runaway horse in a dynamic posture, with a burst of dust from the moving hoofs as well as the body and head at a near 45-degree angle to the ground.

As with the previous picture, it is often the secondary cues—such as the lasso, the bearing of the rider as he turns in the saddle, the dust thrown from the ground—that contribute to the overall dynamic quality of the photograph.

This photographer is completely familiar with her subject and has perfected a sense of timing geared to her subject's characteristic movements. Let's now consider ways of developing such skills with concern for rapidly changing situations where we cannot see individual segments of a motion.

In the same vein, consider the examples on this page and the next by professional photographer Donnette Largay. In both of her pictures, Largay has been able to capture a specific segment that represents the total action. In the case of the horse and rider in the snow, she caught the raised foot of the horse with the rider smiling and looking right into the camera. What visual cues are telling us the horse is in motion and not just standing still and raising a foot? It is the spray of snow around the horse caught as

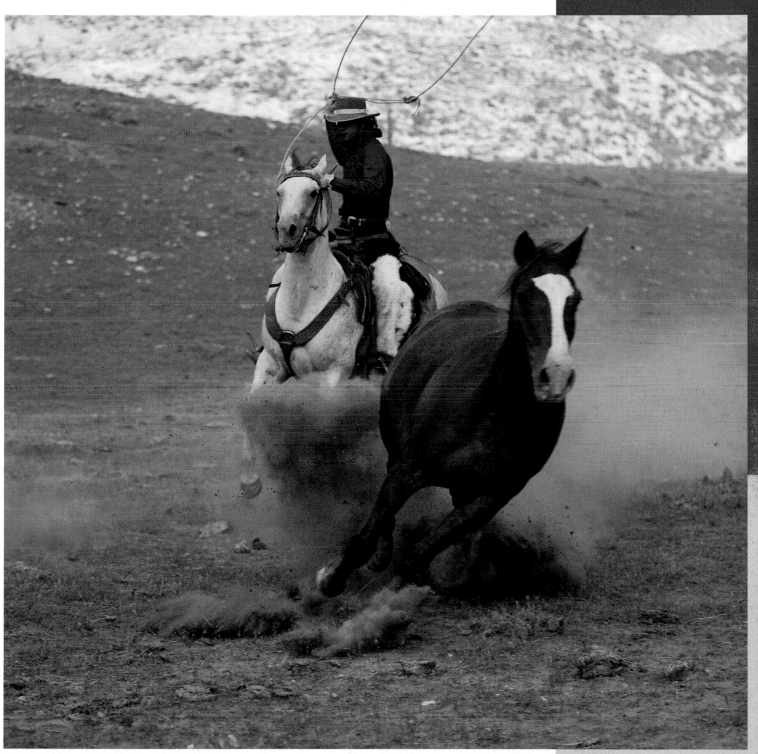

© Donnette Largay

Detecting a Direction and Finding a Pattern

Since you can't see the exact representative moment for an action photograph before it happens, the secret to dealing with this limitation begins with a quick analysis of the whole movement. A skillful fast-motion photographer is attuned to the direction, pattern, and rhythm of a movement, and learns to press the shutter when he or she feels something is about to happen. That is what a sense of timing is all about: Anticipation based on observation. Instead of shooting blindly, you can increase the chances of success by looking for purpose and patterns in a movement. Needless to say, it also means having the camera at its optimum settings as discussed in Chapter 3.

Some situations lend themselves very well to the strategy of looking for directions and patterns. For example, most dancers have very controlled, directed, and frequently predictable movements. Stage dancers will characteristically repeat various steps, giving the alert photographer a second chance to anticipate when to press the shutter for either a single frame or a burst. Likewise, waves crashing on a beach or racecars burning around a track also follow a pattern of predictable movements. Even speakers at a podium will repeat various mannerisms and gestures that can be anticipated by the photographer who picks up on such idiosyncrasies. The idea is to learn to see such patterns and the direction they are taking in order to develop the timing needed to capture those key photographic moments. Let's take a look at this process by examining situations in which a series of shots were used to record a whole motion.

Soccer

In the soccer sequence on the opposite page, I have included three shots leading to a score. Here the direction was obvious: The player with the ball gets as close as possible to the goal with a good angle to take a shot. The overall pattern on the field was also predictable. The defenders were moving to block the kick or get the ball away from the attacker. When I saw this developing, it came down to the challenge of timing the speed on the field, and selecting which part of the shot I wanted.

In most sports photography, the play is typically recorded over several frames using a continuous or sequential drive mode. In these soccer pictures, I used a drive speed of 8 frames per second (fps) at 1/2000 second with a zoom lens set at a long telephoto focal length, shooting from the sideline. I framed the picture to include the goal area in hopes of catching the ball in the net. I pressed the shutter button as the attacking player was about to kick the ball. The first frame (not shown) failed because the attacker was blocked by a teammate in the foreground. The next three frames caught the whole motion of the score after the kick, with the ball ending in the net. Any of these shots could have been selected to show the drama of making a goal.

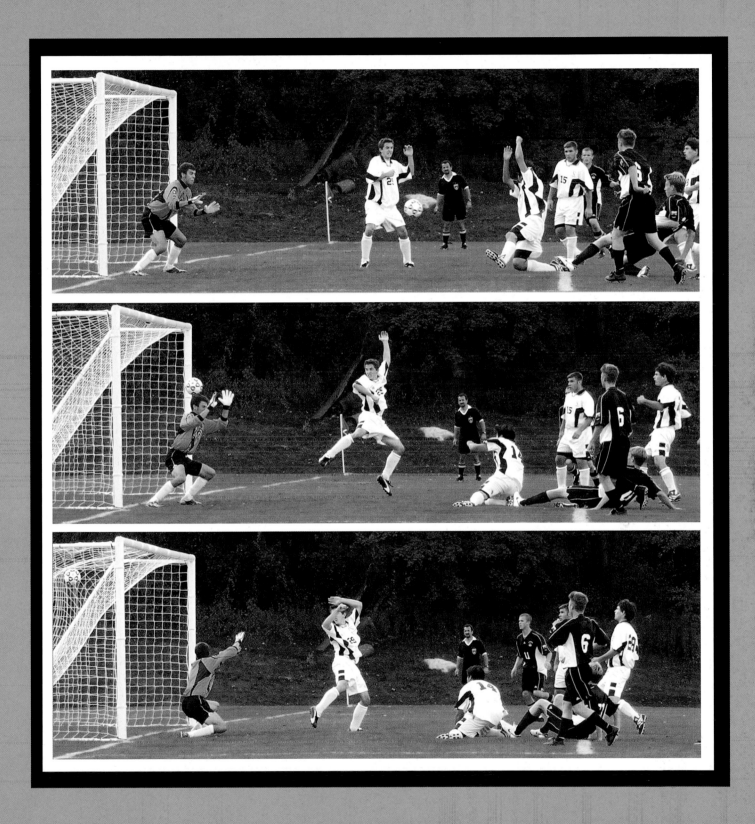

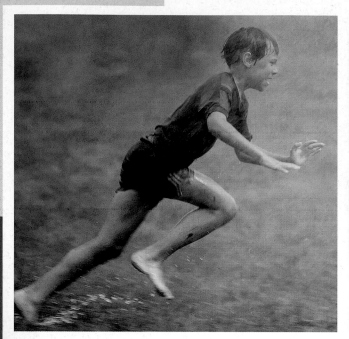

At Play

I was faced with a situation, when seeing a group of boys taking turns sliding in puddles, that needed more than one photo to successfully capture and convey what was happening. Actually, several boys were playing around a sprinkler at the time. The direction was clear, as was the pattern of their movements from start to finish. They ran through the sprinkler toward the mud puddle in a sequence of run-dive-land. My decision came down to how many images I would need to represent the whole motion. After watching for a few minutes, I thought just three shots would be enough: the running approach, the dive with arms out to break the fall, and the slide through mud that seemed to swallow each of them. With the camera set at 6 fps and 1/250 second, I took the three pictures seen above. I had to photograph five different boys to get the timing just right. While photographing, I did not realize the mud was completely engulfing the boys until later viewing. Once again, the still photograph can show something the human eye misses.

The Rodeo

I was invited to photograph a Navajo rodeo but had no experience with this type of action. So I took a few minutes to watch and see if I could identify any patterns. I noticed that the animal during the bull-riding contest would usually burst out of the pen in a straight direction, but then typically spin left or right to try and unseat the rider. I decided to compose the shot just as bull and rider came out of the pen, face on to my position. A pattern of basically up and down movements developed, along with a spinning motion of the bull. I took the shot below to the left just before the bull began to turn sideways, using a shutter speed of 1/650 at f/5.6 for an isolating effect on the rider. The rodeo clown sticking out his hand was actually a lucky addition.

As I continued to observe the riding action, I became intrigued with the way the riders were unseated. This moment in the pattern could be anticipated by watching the way the hips of the rider's body gradually (but often quickly) lost a solid position on top of the bull. It was tempting to watch the upper body with the hand flying in the air, but it was really the hips that dictated what was going to happen. I decided to pay close attention to that movement through the viewfinder. As soon as I saw the hips come off the saddle I begin shooting at 6 fps, eventually capturing the image below to the right, which was the fifth shot of a 10-frame burst. Luck was with me because the bull had turned to become perpendicular to my position, giving a frame-filling view just as the rider was being thrown. Unlike the previous bull-riding example, I wanted the background in focus to catch the spectators

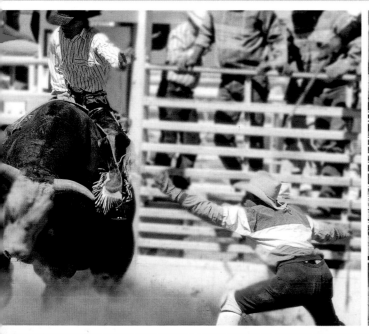

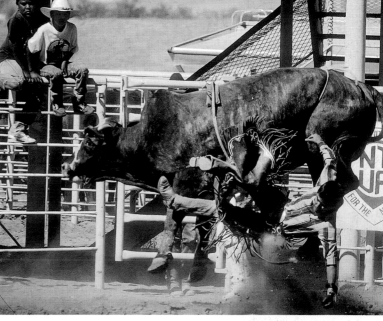

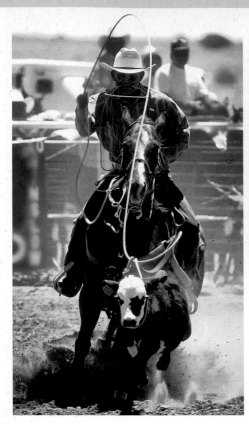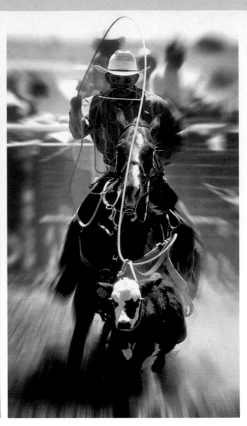

watching the action. I set the camera at f/8 with a 1/1000-second shutter speed. When it came to the final crop in the computer, I noticed that the young Navajo boys were watching the rider. There were also several other people farther beyond who were looking away. I cropped them out to produce the almost square framing of the final image. This square crop actually helped reinforce the downward direction of the dislodged rider.

I was also in the head-on position outside the ring for the calf roping competition, and captured the image seen in the frame above left. I liked the shot, but felt the frozen motion was taking away from the speed of this event. I consequently decided to add a zoom effect in the computer using the Zoom Filter in Photoshop (10% Filter > Blur > Radial Blur > Zoom), with the middle frame as a result. But this effect was too much for me, so I selected the area of the picture that I wanted to remain clear using Photoshop's Lasso tool, and then selected the outside area (Select > Inverse) and applied the Zoom Filter as before. The result (above right) was an interesting combination of a fast shutter speed capture and a slow shutter speed refinement.

At the Ocean

Photographing waves is a relatively easy action shot since there is a predictable pattern. You should be able to isolate a single dynamic wave like the one (right top) that which was taken at 1/350 second, or portray a more serene feeling with flatter, gentler waves lapping at the beach (bottom photo, at 1/250 second). It is more difficult to record the shape of larger waves with a curl, as in the example to the right, taken from a high perspective at 1/1000 second, because stronger and larger waves often do not come into the beach evenly spaced. The bottom line is that you should be prepared to take several frames and to be frustrated by these irregularities. Wave formations in more active seas can really try one's patience, but can also deliver spectacular results.

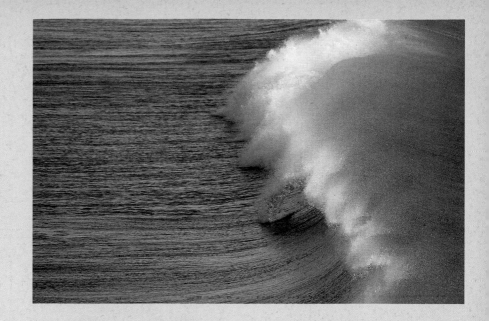

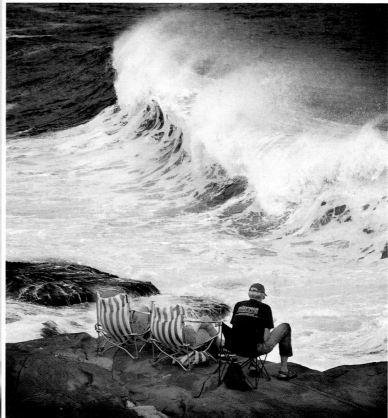

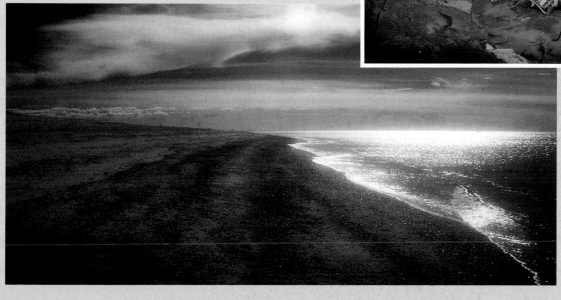

water coming off its surface. Of the four pictures in the illustration, the second from the top shows the largest volume of water, whereas the bottom frame is unique due to a larger funnel of water that has been caught bridging the ocean's surface and the fluke. The main challenge in this series was the lack of control over direction. The angle I wanted was straight on to the back of the whale, as in the top three shots. But I simply had to wait for the boat and the whale to line up, and then time the movement of the fluke as it came out of the ocean to get the streams of water as they rolled off.

To take the picture on the opposite page, I was in an enclosed sledge being pulled by a snow machine across the frozen ocean during an assignment as an expedition photographer in the Arctic. I looked out of the blue tinted Plexiglas window to see one of the Inuit guides on another snow machine splashing through the water that was accumulating on the ice. At first I wanted to use a slower shutter speed to blur the water coming off the rails of his machine. Since we were both moving at the same speed, he and the machine would be recorded in focus. This is a variation on the pan technique covered in chapter 5. Thus, his direction was parallel to mine and his driving pattern was consistent. But my sledge and his snow machines were both bouncing rather hard over the irregular ice. That meant having to use a fast shutter speed, so

Photographing during a whale watch is again a matter of picking up on a direction and pattern of behavior. My goal in the photos above was to catch the fluke of the whale just as water came streaming off the surface when the animal began to submerge. Speeds of 1/1250 to 1/1600 second were used, and the idea was to catch this segment with several different whales. Each whale's pattern was quite consistent. First its back would appear and then the fluke would come up out of the water. I had only a few seconds to catch the fluke with all that

I switched to an action-freezing composition. The 1/750-second shutter speed froze the chunks of ice and splashing water from the rails in mid air. I also tilted the camera for a dynamic angle. After a few shots he noticed me and pointed, which gave a little something extra to the shot.

Spontaneous Actions

There are many other situations in which the direction, pattern, and rhythm of the action are far more complicated, unpredictable, and more challenging to follow than the previous examples. Sometimes there is so much going on that the choices seem overwhelming, like when tracking the movements of children playing in a group or photographing a number of people on a crowded dance floor. There will inevitably be some awkward subjects within the crowd in both situations. And even predictable actions can have unexpected changes in a pattern, as pointed out with waves crashing on the shore. What does one do when there seems to be more chaos than predictability?

The best approach is to select and concentrate on specific subjects. Trying to catch everyone so that they all look dynamic during a spontaneous group activity is a low percentage shot. The solution is to isolate one or two couples, or two to three children in a group. In the case of a sporting event like a football game, it often pays to concentrate on one area of the field. Chapter 6 has many examples of this approach when photographing sports. Commercial television covers large and unpredictable events by assigning cameras to specific areas or play-

ers, and the editor in the control room selects which shots will actually be broadcast. Always remember there will be shots that don't work in any fast-action situation. But there will also be successes and surprises that will teach you something for the next time.

In the beginning, fast action photography is a world in which the photographer takes chances to see what can be captured. It is worth repeating: Analyzing mistakes often tells you as much, if not more, than your successful shots will. Eventually one develops a way of operating the camera almost reflexively. This may be easy to state in words, but it is a skill you have to constantly work at and refine while learning from failures.

Supreme Timing or Just Luck?

Sometimes capturing unique segments of a fast-action situation may seem to be a matter of pure luck. Consider the photo above, where the young "Polar Bear" swimmer has been caught with a great expression just as he is about to enter the icy water. My timing was such that I captured the moment when he appeared to be walking on the water. Was it pure luck, or just great timing? Frankly, it was a little of both. First, I sized up the situation by estimating the direction that the swimmers would take. I then took a position at an angle that would include some of the spectators taking pictures, thereby helping to establish the feeling of the event (a charity swim in the icy lake). Next, I made sure no one would block my view. Finally, as soon as the word was given for the swimmers to run into the water, I began recording at 8 fps to capture the whole entry, plus some other shots of them quickly getting out of the water. Later in the computer, I found this "walking on water" keeper.

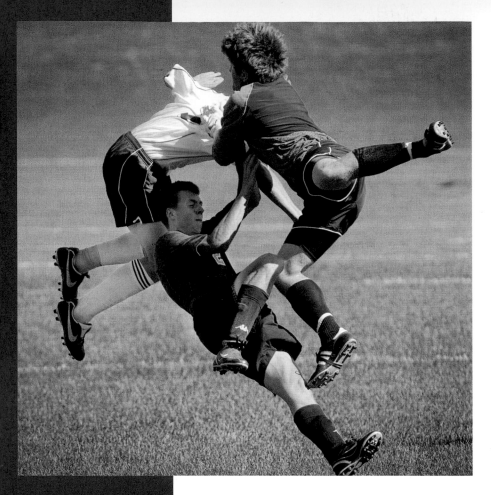

However, I worked very hard to get the final result in the baseball picture below. First, I positioned myself high in order to isolate the two players with the field serving as background. Next, I timed the batter's swing by picking up on his pattern of body movements just before swinging. As he began to swing, I pressed the release with the shutter set at 1/1000 second so that the 8 fps rate would catch a ball somewhere in front of the catcher. Only the exact position of the ball (entering the catcher's glove) was left to chance.

But good fortune certainly has its place, as evidenced by the soccer picture above. I had taken a position to capture goal shots, striving for an uncluttered background rather than having the goal net behind the players. My intention was to get a clear shot of the goalie catching the ball. Instead, a mid-air collision occurred as I fired a sequence at 8 fps. The result was pure luck, as I had no indication that this was going to happen.

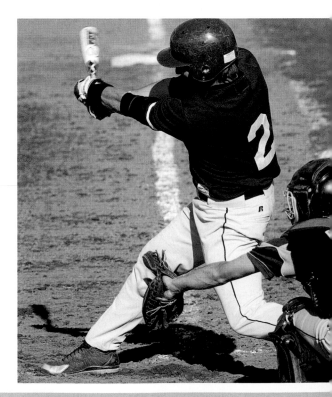

Moving Backgrounds

A fact to remember is that background areas will often change when photographing a subject that is moving horizontally or vertically relative to the camera. You may start with a clean background and end up with a busy one. Thus, it is always good practice to check this out when working with a moving subject. Here are some examples.

The series above consists of four images of an Inuit hunter returning to base camp along the frozen ocean's edge off Baffin Island in Canada. I was located about 100 yards outside the camp and photographed him with a 500mm lens at about 1/750 second as he returned. Notice how the back-

ground changes across the four pictures. Of the four, I only like the background in the third frame. When photographing a subject in motion, it is important to pay attention to the background as a critical element of the final composition.

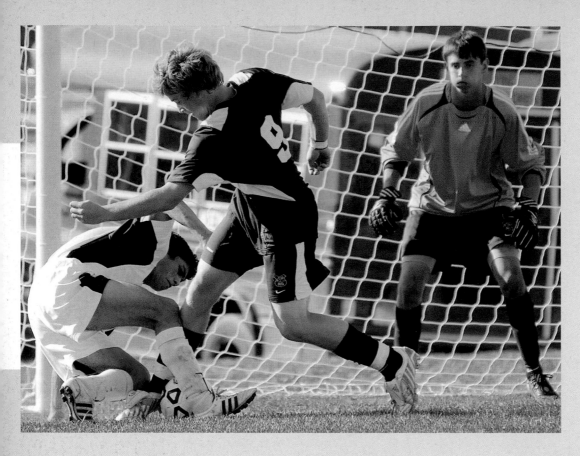

I will usually aim for a plain background, one that has a minimum of interfering elements. But even when working with a large plain background such as sky, you have to pay attention to possible interfering patterns, like a horizon line cutting through the center of the main subject. When you cannot avoid having busy backgrounds, an alternative is to crop as tightly as possible around the main action, as I did in the soccer action above. I liked the capture of the players struggling in front of the goal, but find the bus in the background a distraction. The final crop excluded people who were getting into the bus. But there are also times when I will try to work in a background, as in example the lacrosse photo (left) where the scoreboard serves as a related backdrop to the huddling players.

How Fast
is Fast Enough?

A question you may have is, "How fast should I set my shutter speed for various motion situations?" If your goal is to freeze all action—and there is plenty of light—then choices like 1/1000 second and higher will stop just about any movement. But the situation may not allow you to use such a high speed, or you might have selected a shutter speed that is simply too fast for what you intended to show.

The water scene (above) was taken in the gray light of an overcast day. I wanted enough depth of field to catch a sharp image of the otters, and a shutter speed fast enough to freeze their movement. So I pushed the sensitivity up to ISO 1600, with a speed of 1/350 second at f/11. I thought it would be fast enough to get a sharp rendering of the animals as they frolicked. But just as I clicked the shutter, one of the otters suddenly reared up and shook his head rapidly, resulting in an image that is partially blurred. Is the shot a failure or does the blur reinforce the quick behavior of the playful

otters? Sometimes the answer is what you as the photographer decide. At the end of this chapter I talk with professional photographer Zenon Bilas (who deals with powerboats and water skiers). His job is to produce razor sharp images of these fast-moving subjects, and his solution is to use very fast shutter speeds.

The other side of the coin is to avoid a shutter speed that is too fast for the subject's movements. This typically happens when it makes sense for part of the subject to be blurred in order to convey motion, even while using an action-stopping shutter speed. The floatplane in the top frame (left) was captured at 1/850 second. This speed made the propeller seem to have stopped; whereas a shutter speed of 1/250 second in the middle frame is too slow since the propeller all but disappears in a blur. In the bottom frame, a shutter speed of 1/350 second seems to give just enough of a blur to make the point.

The interesting picture of the bicyclist (opposite page) has been rendered as a solarized black-and-white image using the Black and White Solarizing Filter selection in the software program, Nik Color Eflex Pro. The biker was photographed at 1/500 second to produce sharp focus, but this fast speed also made it seem as though his bike was not moving. The same is true of the

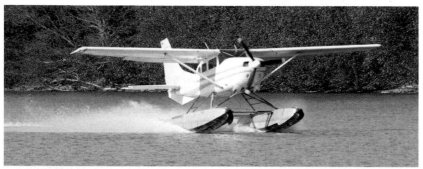

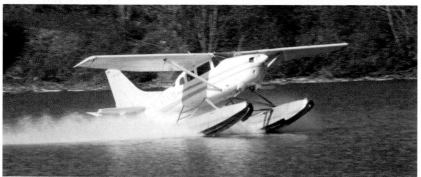

motorcycle rider (right upper) where his wheels don't show any movement. It seems as if the rider was standing still balanced on the machine, even though the woman seems to be reacting to the motorcycle as it goes by. In the lower version, I selected and then blurred the wheels in the computer, also adding a dynamic angle to the composition. I then applied a slight barrel distortion to stretch the motorcycle in order to reinforce the sense of forward motion.

Profile

Boating and water skiing magazines are filled with photographs of fast moving boats and skiers who seem to fly across the water. This is a specialized area of motion photography that not only requires camera skills, but also knowledge of the equipment and the sport involved. Anyone who has picked up one of these magazines or advertising brochures has probably seen the work of Zenon L. Bilas, who has produced images professionally for the past ten years. A seven-time U.S. barefoot water ski champion, Bilas' award-winning work appears regularly in industry publications in North America, Europe, and Australia. He is also a frequent contributing writer on boating and water sport topics. His basically all-manual approach to this form of action photography is an excellent example of how one professional deals with specific photographic challenges.

Question

The typical shot of a speeding pleasure boat seen in magazines and product brochures is a very sharp, action-freezing image. How do you deal with the motion of the chase boat you are in to get the frozen action, as demonstrated in the shots on the opposite page? Are you using any special equipment, such as vibration reduction lenses?

Answer

Most action photographers use equipment with lots of auto functions. I prefer single focal length, manual focus lenses on a camera that has a drive option for fast continuous shooting. I like having things uncomplicated with just a prime lens in front of me and that's it. I freeze the action with a higher shutter speed, typically 1/1000 second. This is fast enough to stop the action whether I am in a stationary position or riding in a photo boat. Sometimes for water ski and wakeboard photography, I

Zenon L. Bilas, © Tom King

© Zenon L. Bilas

will go up to 1/2000 second to get a little more sparkle from the droplets of spray that have been "frozen" in the air. The usual aperture is between f/4.0 and f/5.6 (at ISO 100), with the focus point on the model who is generally seated in the middle of the boat. These settings give me plenty of depth of field to keep a boat as large as 30 feet in length in sharp focus.

The photograph of the sport jet boat (above) was made from an adjacent photo boat. As the driver added to the feel of action by turning the boat away from me, I took the shot at f/5.6 and 1/1000 second to create a sharp image with sparkling spray from the jet propulsion.

The photo of the bass boat (right) was made from a stationary boat. I used camera settings of f/4.5 and 1/1000 second. The light settling

into the Everglades was beautiful, and from my position, I was able to give a wider perspective to show some of the lush flora and character of the surroundIngs.

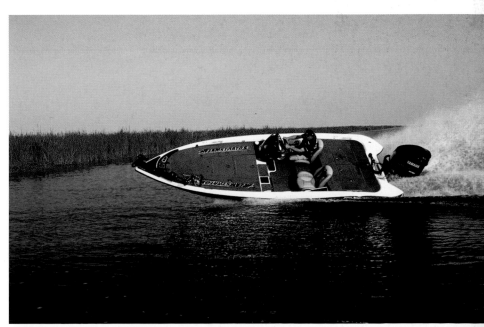

© Zenon L. Bilas

When shooting boat to boat, I sometimes go down to 1/250 second or even 1/125 second to create a blur in the boat spray. However, I do so only when the water is glass smooth and the photo boat has minimal vibration. A shutter speed of 1/30 second or slower will create more interesting blurs of the spray. However, at this slow shutter speed you really need a Gyro to keep the camera steady and insulated from vibrations. Because I have been a boater for 35 years, I can easily detect any boat vibration when shooting, and that affects the shutter speed I use.

Question

Looking at your extremely dynamic ski pictures, one can't help but notice how you sometimes seem to put the viewer on the surface of the water right there with the skier (opposite page). How do you do this, and what sort of focal lengths do you generally use?

Answer

I took both of these photographs from a stationary rowboat. When the slalom skiers approached my position, I leaned outside the boat as close to the water as possible. This is the exception to my rule of never touching the structure of the boat to avoid vibrations. The camera was manually pre-focused on the spot where I wanted the photo to take place. Because I'm a competition water skier, I can anticipate what will happen in the few seconds of action that will take place at that spot.

In most cases, I try to get close to the subject for the more natural look produced by a normal lens or a wider lens, such as a 35mm or even a 25mm on my full frame (24mm x 36mm) camera. These lenses allow me to get close enough to create the intimacy I am after. In the case of these two slalom photographs, however, I needed to stay at a safe distance from the skiers, so I used the 180mm lens for both. Their boat is traveling at 36 mph, and the skier accelerates up to 60 mph. The action is exciting and I must be on my game to get a strong composition, all in focus, at the precise moment of the shutter release.

The top photo to the right is a good example of this timing. Seconds before he approached a slalom buoy (outside the frame), cloud cover obscured the light. I saw a natural glow through the cloud cover that gave the scene an icy blue aura. That glow made for an interesting opportunity, but it also made it difficult to photograph the skier because I had to quickly adjust to an f/2.8 aperture while the shutter remained at 1/1000 second. Exact focus on him was difficult with the limited depth of field, but the kind of eerie light made for a photograph that's more than just an action water ski photo.

The bottom picture was made at around f/4.5 at 1/1000 second. The water level perspective and the stop action of the fast shutter speed produced this exciting and exhilarating capture of the skier as he turns and accelerates up to 60 mph right in front of me.

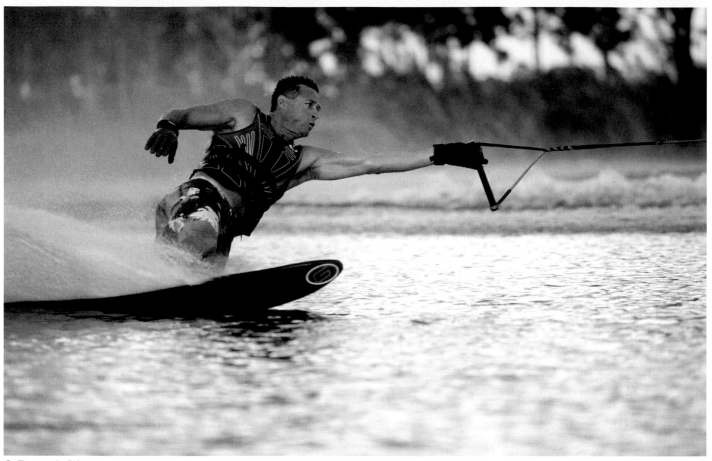

© Zenon L. Bilas

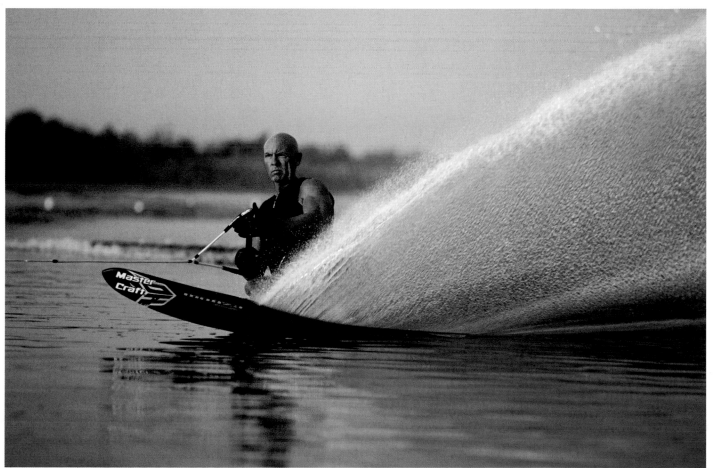

© Zenon L. Bilas

© Zenon L. Bilas

Question

Some of your ski pictures are really remarkable for how close you seem to get to the skier. How do you get this type of dynamic result? In particular, was the above photo taken with a telephoto, and did you use any fill flash?

Answer

As I mentioned, I favor wide-angle lenses, but there are times when I need to use telephotos. For example, to obtain a compressed effect or during a tournament when I have to take a position farther away from the action. Also, I might well need one when photographing a skier or wake boarder on a 75-foot line from the same boat. For all of these situations, I find that 300mm is just the right focal length to fill the frame with a detailed view. But in most cases I want to get as physically close to the skier as possible, which is why I really like wide-angle lenses for action water ski photos, as long as I can do it in reasonable safety.

In the picture you are asking about, we put the towrope for skier Mikey Caruso on a boom. That is, a vertically mounted pole that extends from the side of the boat. I'm in the same boat, leaning over the gunwale just a few feet away from him. That puts me close to the action and the surface of the water. The boat is traveling at 40mph and I used a 35mm lens. As I viewed the action through the camera, I could see that the scene became more dramatic as I leaned farther over the gunwale to get even closer to Mikey and the water. The sun went behind the clouds a bit during this pass, so I added a touch of fill flash, which dropped the camera's maximum flash sync shutter speed to 1/250 second. That slower shutter speed produced an interesting blur pattern in the water splashing around the skier.

Question

You are constantly working in a wet environment with lots of splashing water. Do you use any special waterproof housing for your SLR cameras?

Answer

I don't use waterproof housings. Rather, after 35 years of experience in boats and as a professional water skier, I know exactly what the spray will do in both water ski and boat photographs. But, when I'm in a difficult position in which the camera could get wet, I will use a lighter weight, inexpensive older camera. This lighter set-up, with a prime lens, also allows me to push the limits of my position and camera angle that would otherwise be difficult to get with a heavier camera system.

One important point to keep in mind is that I work with pro skiers and professional boat drivers. They know how to make exciting photo opportunities while maintaining a high level of safety for both personnel and expensive equipment.

Question

The photo on the opposite page, above, and particularly the one below, have a fine art look that is quite different from the commercial look of your other work. What was your motivation for these shots and what equipment was used?

Answer

Neither of these were planned photos beofore we started the sessions. But when I saw sky conditions changing to produce a wonderful golden light complemented by blues and glass-like water during the shoot for the top picture, I jumped on the opportunity to go from an action sport photo to a fine art photo dominated by backlighting.

The light was a beautiful color for the backlit image (lower picture), and I decided to use some fill flash knowing that the flash detail in the spray would produce an interesting effect. I was in the same boat that was towing the skier. Using a 35mm lens, I wound up really close to him as he was "footing off the boom." The maximum flash sync speed of 1/250 sec-ond slowed down the spray enough to cause the blur pattern in the water. Many have said the barefoot photo looks like a sonogram of an adult.

I'm influenced by all types of photography, from portraiture to landscape, so when the opportunity presents itself to produce an image that goes beyond an action sport photograph, I am ready. Again, it all goes back to my choice of using an all-manual approach with single focal length lenses that permits my creative juices to flow. I'm constantly connected with exposure values, point of focus, and perspective in each frame. Then it's up to me to find an idea, then frame and compose it in a way that makes the photograph interesting to the viewer. I don't take a huge number of exposures, hoping for a good image by accident. As famed photographer David Burnett once said: "Make every frame count." That's my Modus Operandi, too!

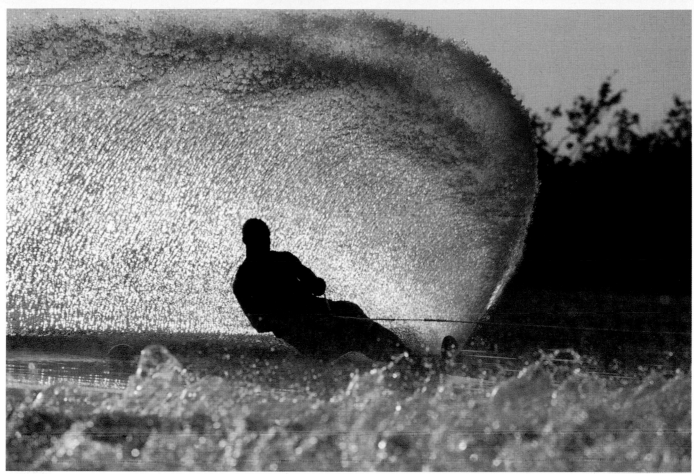

© Zenon L. Bilas

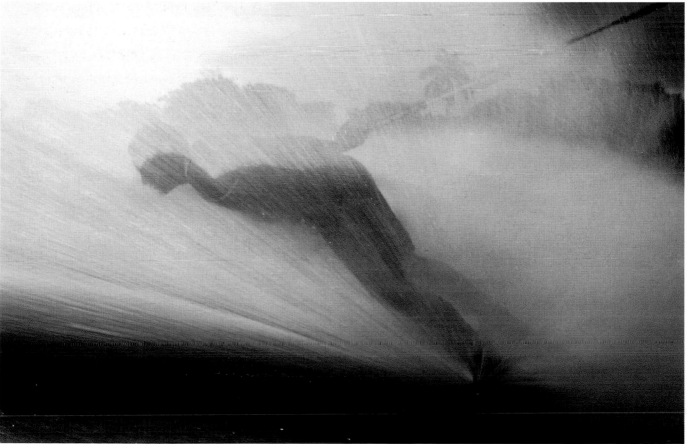

© Zenon L. Bilas

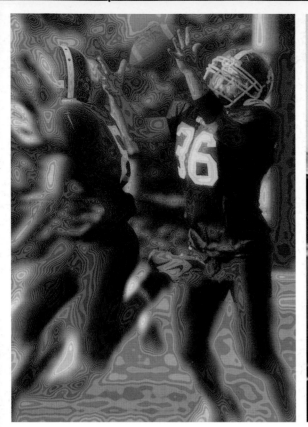

5 Using Slow Shutter Speeds

If using a fast shutter speed freezes a moment of action, a slow shutter speed will spread that moment out over time. As a result, the image will appear blurred, conveying not only an illusion of motion, but also the passage of time. Slow shutter-speed photography will often appear ethereal, which sometimes evokes comparisons to the 19th century Impressionist School of painting. This is logical since many of those innovative painters were interested in portraying time and motion in their work. They also characteristically violated many of the formal rules of composition, as the photographer using slow shutter speeds will often do as well.

In comparison to the use of fast shutter speeds, slow shutter speeds offer a greater range of possible effects. That is, with fast speeds, once you reach a certain point and the action is frozen in the recorded image, increasing the shutter speed will not produce any further significant change. On the other hand, using progressively slower shutter speeds leads to a range of different results. Specifically, the appearance of a scene can be influenced using one of five different approaches. They are: (1) keeping the camera still while a moving subject blurs, (2) moving the camera to produce a blur of a stationary subject or exaggerate the blur of a moving subject, (3) zooming through different focal lengths during a slow exposure, (4) following a moving subject with the camera in a panning action, and (5) taking the picture from a moving position such as an automobile. Each of these approaches will be considered in this chapter, pointing out key characteristics with examples and suggestions for creative applications.

Holding the Camera Still

As I have been emphasizing from the beginning, it is important to think first about how you want to use the presence of motion or the illusion of time passage as a language of its own to add something to a photograph. Accordingly, it is important to keep some basic characteristics of slow shutter-speed photography in mind. First, the slower the shutter selection, the more pronounced the impression of speed, as well as the sense of time passage. Continuing to slow the speed eventually produces photos that enter the realm of abstraction. Second, don't forget the role played by those parts of the picture that are not in motion. As pointed out in the composition chapter, these stationary points serve as visual references to movement in the scene. To have them appear sharp means keeping the camera stable using a tripod, a beanbag, or some other solid base (though you may be able to hand hold if your lens or camera has a vibration reduction function). Third, consider those areas in the scene that may also be moving but which you want to keep sharp, so they don't interfere with the appearance of the main motion. For example, you might want to select a shutter speed slow enough to blur the movement of waves hitting a beach, but not the clouds overhead. Dealing with this third factor can be challenging, and the best advice is to try different shutter speeds and compare the results.

With all this in mind, let's now consider various creative ways that a slow shutter speed can be used to add a sense of motion and/or time to the final image and, in some cases, make that motion the most important aspect of the picture.

The Subtle Use of Blur

In the opening chapter, I said that conveying the illusion of motion and the concept of time could be done in ways that are quite subtle. The three images on the opposite page illustrate this subtle use of image blur. In the baseball picture, the blurring speed of the ball is a visual cue for the potential danger to the batter. It is more effective than an image recorded at a faster shutter speed that would render the ball as sharp. Actually, I had set the shutter speed at 1/125 second for this shot knowing that was fast enough to freeze everyone, but slow enough to cause a motion blur of the batter's swing. Instead, I wound up recording this moment.

In the landscape photo on the opposite page, the recording of rain in the desert presents the same basic choices as the snowfall illustration in Chapter One (see page 17). That is, the rain could be recorded as

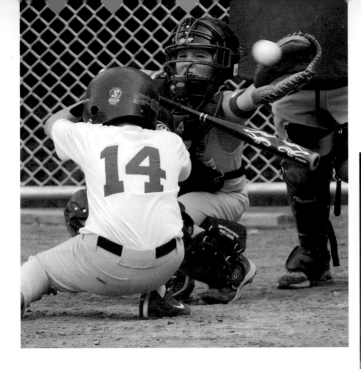

streaks with a slow shutter speed, or as distinct droplets frozen in mid air with a very fast shutter speed. In this photo, a shutter speed of 1/30 second has blurred the droplets into a soft sheet that is blended into the sky.

I wanted to convey the presence of a strong arctic wind while photographing the head of the research expedition in the photo to the right. I selected a shutter speed of 1/60 second, knowing that was fast enough to render the subject sharp but would blur anything in motion, such as the flag and the fur on his hood. The result of this setting allows the strength of this biting wind to be visible in the composition. In all three illustrations, a faster shutter speed, such as 1/500 second, would have rendered everything sharp and may have consequently deprived these pictures of the added quality of motion.

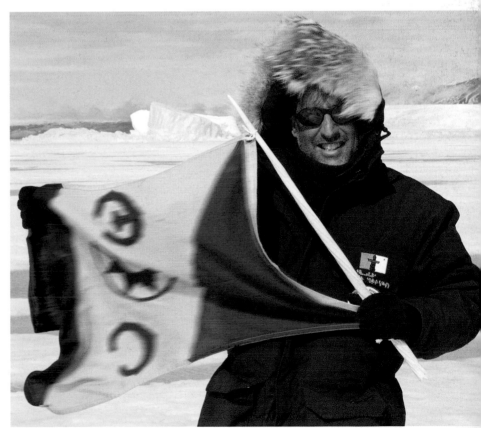

Camera-to-Subject Distance

The highway photo, taken at 1/30 second, shows the influence that subject-to-camera distance can have on blur in the photo, as well as showing the effect of a wide-angle lens. Notice that the vehicles in the top third of the picture appear sharp, while those closer to the camera appear progressively blurred. The use of a 24mm lens from a high perspective exaggerated the size of cars nearest the camera while reducing the size of recorded areas farther from the camera. Thus, because of the relative differences in the distance traveled by near and far vehicles during the exposure, those in the foreground exhibit a greater pattern of blur; that is, compared to the far vehicles, the closer ones move farther within the frame. Whenever faced with a situation in which the camera is recording such discrepancies, it is a good practice to base the shutter speed selection on the subject(s) that are closest to the camera position.

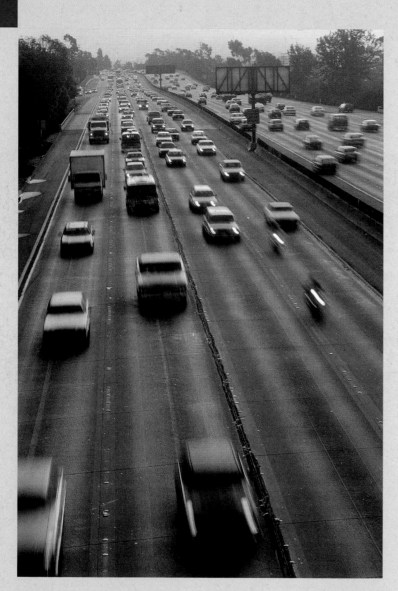

How Slow is Too Slow?

As the shutter speed becomes slower and slower, the blur effect will render a scene less defined or concrete. It is usually best to have enough of the subject's shape remain recognizable. I photographed the base run-

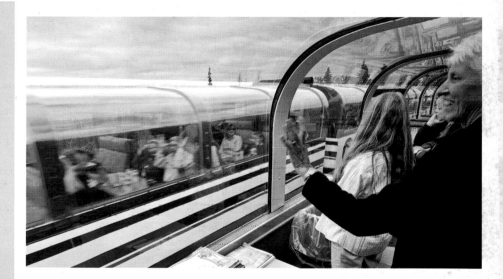

ner (above, left frame) using a shutter speed of 1/10 from a stable camera position. To simulate the way slower shutter speeds would progressively render the subject more abstract, I applied successively higher amounts of the Motion Blur filter in Photoshop (Filter> Blur> Motion Blur) to the center and right-hand images. Obviously, there comes a point when the subject can no longer be recognized.

Stationary Point and Moving Subject

In the picture to the right, I assumed that 1/60 second would be the proper speed to render the people inside my train sharp while not excessively blurring the people in a passing train. I asked the person in the foreground to wave in order to set up a link between the two trains. This shutter speed

was a good choice because it produced enough sharpness to capture some passengers who returned the wave with the "sign of the moose," a popular hand gesture among tourists traveling the Alaskan Railroad system on the way to Denali National Park.

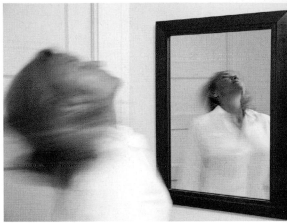

© Diane Franklin

The Unexpected

Using a slow shutter speed can have unexpected results. In the photo above to the left, I intended a slight blurring of the passing bus simply as a way to show that it was moving. A 1/60 second shutter speed did that, but also resulted—unexpectedly—in a haunting depiction of a person looking out the window. This mood was reinforced by the dark outline of someone in the background, along with the drab colors. The dots across the frame are raindrops on the window of the bus I was in when I took the picture. They were sharply rendered, while those on the passing bus were blurred beyond recognition.

One does not usually think of using a slow shutter speed for a portrait, but that did not stop photographer Diane Franklin from experimenting with the arrangement seen in the photo showing her reflection in a mirror (above). The resulting self-portrait renders Diane blurred while her mirror image is relatively sharp. Here is Diane's description of how it was done: "The camera had a zoom set at 28mm, f/4.0, and was mounted on a tripod with the self-timer activated. I started the image with my head down and quickly threw it back at the start of the 1/15-second exposure. The file was then opened in Photoshop to improve brightness and contrast."

Motion at Night

Night photography opens entirely new dimensions for creativity. Colors are intense and saturated, and the contrast of the dark sky makes the available light from sources like the moon or a bustling city seem more exciting. It's a great time to be shooting.

There are many exciting subjects to shoot in low light: moving cars, amusement park rides that are brightly illuminated with dazzling neon colors, fireworks, star trails, and city lights reflecting in water, to name several. No matter what subject you are shooting, keep in mind that a tripod is essential because of the long shutter speeds required. You also want to keep your ISO setting as low as possible because high ISO leads to pronounced noise, especially in shadow areas. Since night photography has a lot of shadow detail, noise must be avoided at all costs to maintain optimum picture quality.

A great example of dynamic shooting at night is seen in photographer Jim Zuckerman's picture of the Coliseum in Rome (top right). He used a 10-second exposure with ISO 200 to capture the craziness of the Roman traffic. Notice how high some of the light streaks are—those came from a bus that passed by.

Exposures at night are tricky because light meters are not programmed to understand extremes in contrast. Therefore, the best approach is to shoot using the exposure modes for Aperture Priority, Shutter Priority, or Program. Then examine the outcome on the LCD screen after you take the picture. If the photo is over or under-exposed, simply use the exposure compensation feature on the camera to make a correction and reshoot.

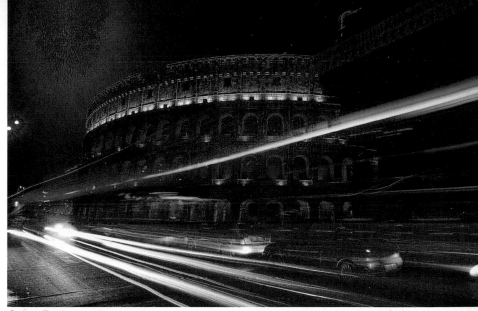

© Jim Zuckerman

© Jim Zuckerman

When Zuckerman photographed a small coastal village in Italy, there was a tremendous storm surge (above, lower photo). Set to ISO 100, this is a 30-second exposure and, during that time, the churning water took on an ethereal quality. The foam from the waves hitting the rocks appears as a glow at the base of the cliff. The lights from the village allowed the camera to pick up the detail in the water.

© Jim Zuckerman

© Jim Zuckerman

The unique shot of funny cars at a raceway (above left) was recorded using a 1-second exposure at ISO 400 with a flash. Zuckerman was too far from the racetrack for his flash to be effective, so he decided to let other photographers who were closer to the track light the scene for him. When the cars accelerated, he opened his shutter and captured the tremendous sense of action in the trailing sparks, plus the frozen images of the race cars from the multiple strobes of the closer photographers. Notice also the flashes from cameras in the audience across the track.

A 2-second shutter speed was used for the photo of fireworks above the Grand Palace in Bangkok (above right). This was a rare situation where the photographer couldn't use a tripod when doing night photography because the crowd was so large there was no room to set it up. He climbed a wall to get away from the crush and, to steady the camera for the long exposure, placed his leather wallet under the camera. That was a good idea in a pinch, but don't depend absolutely on such improvisation. Jim says he managed four sharp pictures out of a total of twenty shots.

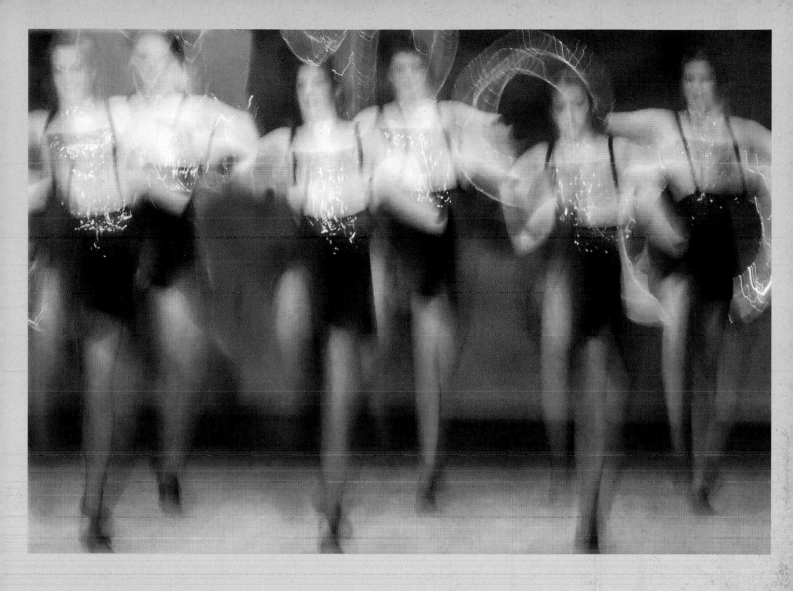

The Energy of a
Chorus Line

In the shot of the chorus line, I wanted to capture the sense of uniformity expected during professional choreography, while also imbuing the picture with the high energy of the dancers. A fast shutter speed would have frozen the dancers in one of their kick patterns, but I felt that would actually deprive the photo from showing the energy I could see on stage. Keeping in mind the need to make sure the subject stayed recognizable, I braced my camera on a monopod, taking pictures using several different slow shutter speeds throughout the number. Because the dancers repeated certain patterns, I had several chances to perfect the composition. It took about eight shots to finally come up with this picture, taken at 1/15 second.

Spinning and Twirling

Besides movements along the horizontal and vertical planes, there are also twirling or spinning movements that make for interesting results when photographed with a slow shutter speed. I photographed a twirling dancer on stage at 1/10 second handheld (right). My intention was to capture her energy as a contrast to her stationary partner. I looked for an angle that gave me a dark background so that the movements with the lighter colored costumes would stand out (remember from the last chapter that it is a good practice to be aware of the impact of the background).

Donnette Largay made the photo of the pizza man, capturing the movement of spinning dough in a classic "always have your camera with you and ready" situation. The camera was handheld at 1/40 second and the picture reminds us that motion subjects are everywhere.

The picture at the top of the opposite page shows the combined dynamism of all the members of this Chinese dance troupe. When they moved in a twirling sequence, I realized that this was a time when they were all doing the same movement and showing a great deal of energy. I saw this motion performed in rehearsal and therefore was ready for it during the regular performance. My camera was on a tripod in a control room above the audience, set at a shutter speed of 1/8 second.

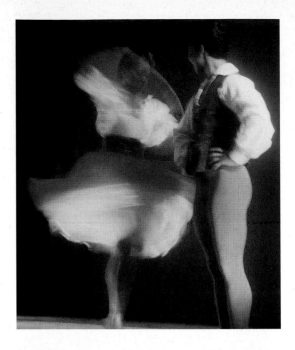

© Donnette Largay

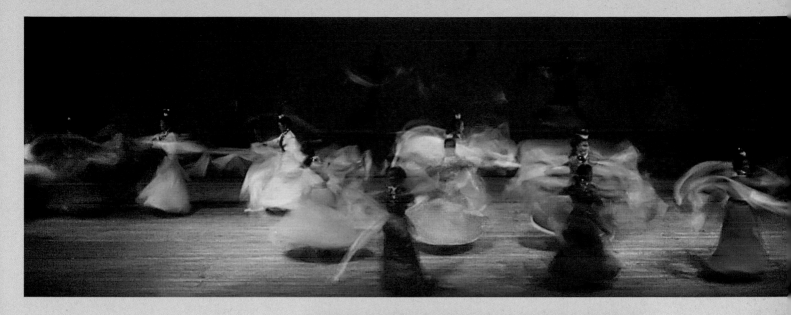

Occasionally, an image can be given a dynamic quality through the addition of a spin filter. The leaping soccer players (right), originally captured with a fast shutter speed of 1/1000 second and rendered very sharp, have been transformed into a blurred spin with an application of the Radial Blur filter in Photoshop (Filter > Blur > Radial Blur > Spin 08%) to reinforce their high energy. The same filter was used in the lower photo to convey the energy of the swinging arms of the two players on either side of the center character. But in order to have the faces remain sharp, I first selected this area with the lasso tool in Photoshop, then selected "Inverse" so that the spin would only apply to the outer areas.

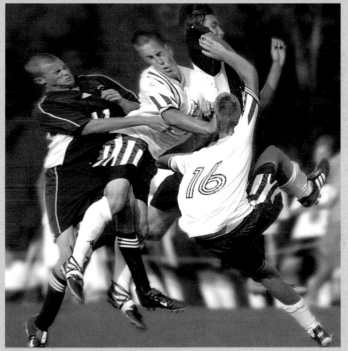

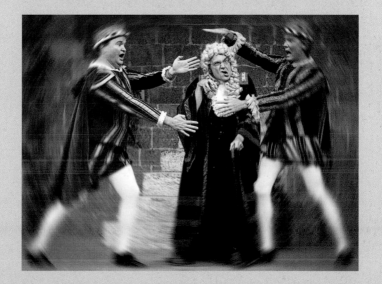

Working with Water

Waterfalls, waves, and many other forms of water scenery are popular subjects for photographers. Here are a number of different scenarios using a stable camera and a slow shutter speed. Remember, in all cases you are dealing with a subject that can have many degrees of movement as well as different forms.

1/125 second

I often use slow shutter speeds to flatten the rippled surface of water in a lake or pond, producing a serene mood. How slow should the shutter selection be? That depends on the amount of movement in the water and how flat you want the surface, as demonstrated in the following examples.

Again, a reminder that it is often best to use a tripod or some other image stabilization device when stationary elements in the scene should be rendered sharply while setting long shutter speeds.

The effect of several shutter speeds, from 1/125 to 4 seconds, can be seen on a lake's surface with ripples from a light breeze (top row). Notice how the surface appears to be brighter as it becomes flatter, since it is more evenly reflecting the light. Slight color shifts can also occur with very slow shutter

speeds, which I did not correct here in order to illustrate the point. This tends to happen if the camera is set on Auto White Balance. A white balance setting for the specific conditions, such as Cloudy in this case, would produce a more consistent result for the four shutter speeds.

A shutter speed of 1/15 second was slow enough to merge the gentle lapping waves underneath the pier in the picture to the right, giving a smooth and languid feeling to the water. This result, along with a Nikon Soft I camera filter, reinforces the ambience of a steamy Florida summer morning. I wanted the shutter speed selection to be just slow enough to smooth out the waves, but fast enough to avoid blurring the moving clouds. This was hard to determine, so my strategy was (as always) to expose at different shutter speeds. In this case I took sever-

| 1/4 second | 1 second | 4 seconds |

al shots ranging from 1 second to 1/30 second. I used a variable neutral density filter to adjust for the changes in light from the different speeds, which allowed me to maintain the small aperture openings of f/11 or f/16 that produce the star pattern here that characteristically forms around small light sources such as the sun peaking through the clouds. The star pattern is yet another of the little extras that contributes to the final impression.

You are more likely to record a texture, or even a mist, across the surface as opposed to producing a flat, mirror-like result when dealing with rougher water. This is the case in the early evening picture of the Florida pier above, taken with a 4-second exposure. When the water is choppy like this, a slow shutter speed will produce a mist-like surface with just a hint of texture. Much longer exposures, often measured in minutes, will tend to produce a lot of mist in the picture that will mask any surface texture, as seen in the photo of the rocky shore on page 22.

There are times when using a slow shutter speed will yield results that teach you something about your subject. This is what happened in the coastal California lighthouse scene (opposite page). It was a dreary, overcast day, so I decided to convey this "blue mood" by recording the scene using Tungsten white balance (light bulb icon), which produced a blue cast. I also wanted to blur the action of the waves so there would be no texture in the water, and perhaps catch some mist in the process. I tried several different shutter settings, from 1/15 second to the 30-second exposure shown

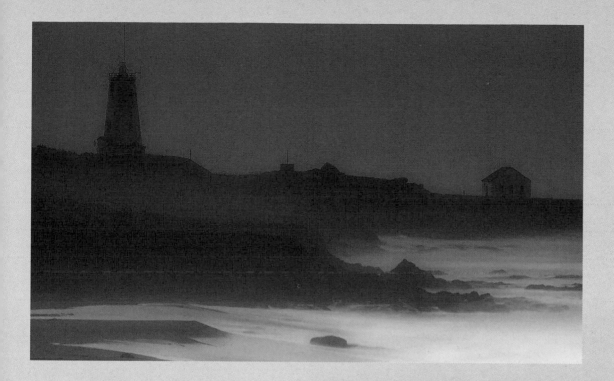

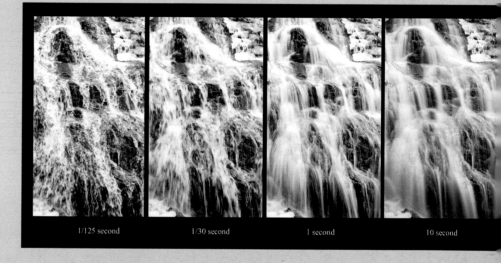

| 1/125 second | 1/30 second | 1 second | 10 second |

here. I also decided to use a 300mm lens to compress the composition, bringing the lighthouse, the rocky shore, and the waves into seeming closer proximity. One element of this scene to which I originally failed to pay attention was the line where the waves hit the beach. Like Jim Zuckerman's photo (see page 123), the water was churning a good deal of foam. During the extended exposure time, this foam was recorded over a wide area and formed a white foreground. So the long exposure time added a separate visual element to the picture. With a faster shutter speed, the foam would only be caught momentarily in smaller areas.

Moving Water

Water that is moving in nature comes in a variety of different shapes and sizes. Also, the volume of moving water will vary greatly, as will the speed of the flow. Waterfalls, river rapids, and rock-studded streams can also yield interesting results because of the natural barriers that interrupt a smooth flow, so an analysis of the scene can be helpful. I approach each of these sit-

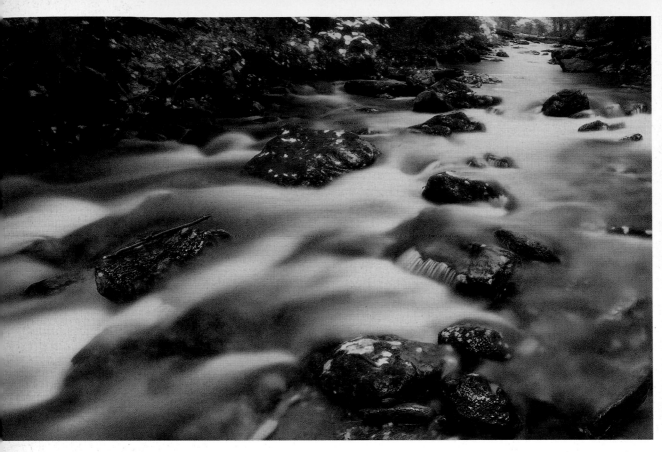

© Len Hellerman

uations as if photographing a great cathedral. That is, a picture of the whole edifice is one option, but there are also many, many potential pictures of smaller sections, and even smaller pictures of close details that may yield excellent compositions.

In order to get an idea of how shutter speeds will affect a particular scene, I often take a series of shots at progressively slower shutter speeds, as demonstrated in the sequence of falling water on the preceding page. The camera's LCD will show a general idea of which speeds might work best. I will then take pictures using the two or three speeds that look the most interesting. When faced with a situation that calls for slow shutter speeds, my habit is to try different settings because I am often surprised by an unexpected look to the subject.

In the case of a stream or river, the presence of rocks will add definite texture to the smooth surface of water when captured at a slow shutter speed. In the flowing stream (above left), I chose an extremely long exposure (30 seconds) in order to flatten the stream as much as possible and isolate the rocks. A wide-angle lens at f/16 was set low to the water to really emphasize the foreground area. Since streams and rivers are flat surfaces that face the sky, they tend to reflect the sun directly, as opposed to waterfalls where the plane of reflectance is perpendicular to the sun. Water is also a great reflector of additional colors that may be present in the sky, such as those typically seen at sunrise or sunset. Photographer Len Hellerman was able to take advantage of this characteristic in his beautiful shot of the Colorado River (above right).

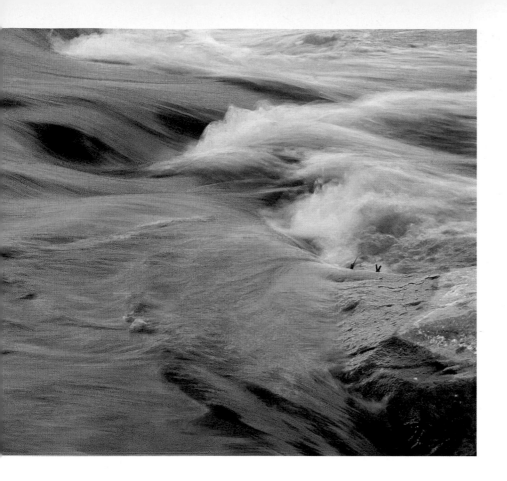

Sometimes an extra long shutter speed, such as the 20-second exposure of the falls (below right), used to record a large volume of water can lead to little more than a great blur, which, in truth, can be rather boring. So to add interest, I prefer to frame the falls with some of the stationary surroundings such as rocks, trees, or undergrowth, and use a wide-angle lens. In this shot, a 20mm lens was able to include the surrounding ledge rocks to contrast with the moving water. A large-volume waterfall also means a lot of spray will be generated that coats the rocks and plants in the immediate area, giving them a surface sheen.

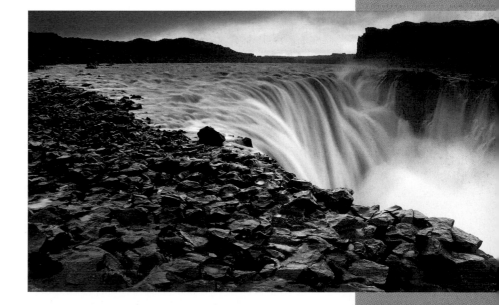

Not to be overlooked is the technique of isolating small areas of a waterfall, as in the photo to the right. A long exposure will capture the unique patterns and textures that water forms in layer after layer around individual rocks. It often takes an exposure as long as thirty seconds, like that used in this example, to produce the build-up of layers that emerge in such a velvet-like appearance.

Other interesting subjects for motion photography include manmade water scenes, such as the one at Caesar's Palace in Las Vegas (below). This picture was taken at 2 seconds using f/16. These are regulated forms of moving water usually within structured surroundings that can easily be worked into the composition. For example, the "S" curve of the pool's edge in the foreground serves as a wonderful leading line into the picture.

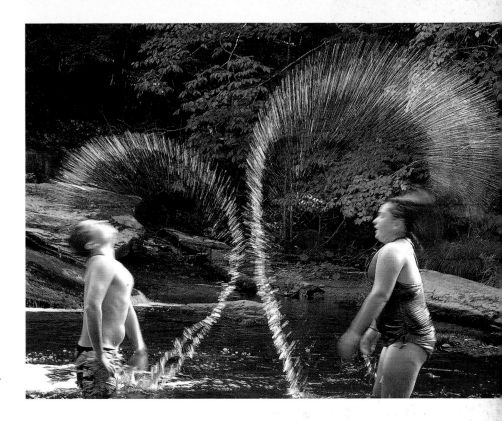

While rocks and ledges are the usual stationary points in a waterfall picture, another technique is to place a person under the falls (above). It is always fun to see your subject's reaction. The key is to have them hold as still as possible so they will be rendered sharp. A 1/40-second shutter speed using a hand held camera with a vibration reduction lens at 120mm did the trick.

Still another representation of water can come in the form of spray and droplets, as seen with the two kids in the picture above right. They dipped their hair into the water and then whipped their heads backwards to form the spray pattern. The lengths of spray shafts such as these will be determined by the amount of water absorbed in the hair, along and the camera's shutter speed. Because she had longer hair, the girl threw off longer shafts of spray. The shutter speed was 1/30 second, and the boy and girl were positioned in the sunlight—but in front of a background mostly in shade that helped make the spray stand out.

Moving the Camera to Produce Blur

As I mentioned when describing the series of photos showing the American flag (see page 60), "freestyling" is a term I use when I set the camera to a slow shutter speed and then move it while recording the picture. This technique characteristically produces streaks of everything in the scene. In fact, since it produces significant blurring, you should take care to make sure the subjects are still recognizable. Though freestyling is simple to explain, it usually takes a little practice to produce a good image. I set the

camera on Manual exposure, often using a shutter speed between 1/2 and 1/8 seconds, and manually pre-focus. It usually works best with the aperture set to f/8 or f/11, and I prefer the soft light of a cloudy or overcast day. The last step is to determine when to begin and end the camera movement, as explained in the examples that follow.

In the picture of the 50-yard marker above, the idea was to produce a blur streak downward from the numerals painted on the football field. I manually focused on them, pressed the shutter and held the camera there for approximately half of the exposure time. I then moved the camera downwards and did not stop until I heard the shutter close. It took about eight tries with a shutter speed of 1/10 second to get the effect shown here. The trick is to review the image on the camera's LCD screen to see how you are doing with the timing of keeping the camera still before moving it to get the streaking.

I was really pushing the envelop with these dancers (opposite top) who were panned at 1/3 second. I then stopped the panning and held the camera as still as possible for the last portion of the exposure. (I would estimate about one-third of the total exposure occurred when the camera was still.) In this case, moving the camera multiplied the sense of movement on stage. Note the long streaks formed by the small bright lights in the background.

Another variation of the moving camera approach is to introduce flash as the camera is moving. In the picture of actor and bodybuilding champion, Joe Bucci (opposite bottom), I moved the camera, set at 1/10 shutter speed, slightly to the left to streak and blur the distant background as a strobe light (set high and to the right) fired. The light of the flash fell off quickly so that only the subject, in his pose, was frozen.

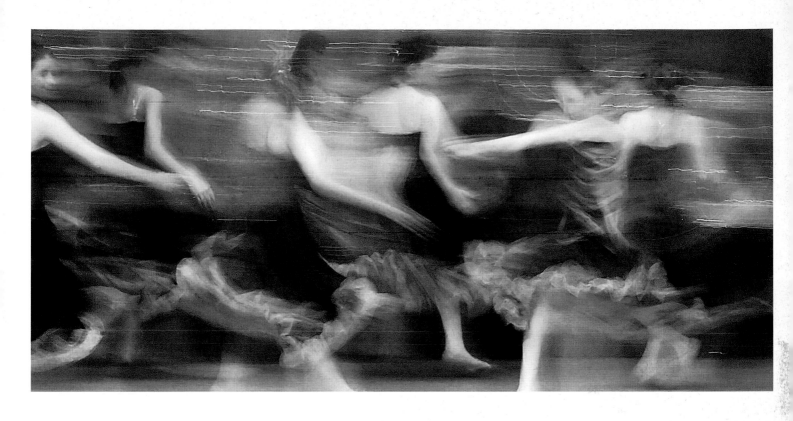

© Jack Reznicki

Changing Focal Length During an Exposure

This so-called "zoom blur" appearance can be produced using a zoom lens or by adding the effect to an image later in the computer using software. When the effect is produced using your camera and lens, a slow shutter speed between approximately 1/4 second and one second is needed so that the changes can be recorded as you zoom to alter the focal length during the exposure. Be aware, however, that focus will shift as the focal length changes. For this reason, I generally focus the lens at a telephoto focal length, and then zoom to a wide-angle focal length. Looking at the shot in the pool hall by photographer Len Hellerman, you can actually see different focal lengths recorded as the lens was zoomed at 1/4 second.

In another example (above), photographer Jack Reznicki calls this freestyling technique "dragging the shutter" because of the slow shutter speeds that are used to achieve the effect. Here he adds a twist by shooting at night and taking advantage of the bright lights of New York City. Setting the ISO to 400 and shutter speed to 4/10 second, Reznicki used an on-camera flash to freeze his subjects, who were within 12 feet of the flash, while rotating the camera to produce streaks and the sense of movement with the available light in the background. The key is to balance the flash exposure and the available light to get a pleasing look.

This zooming technique can also deliver an abstract rendering of the subject while still retaining reasonable clarity, which is demonstrated in the photo at right. The movement in this shot, recorded at 1/10 second, is shown as a smear of the bright headlights from the oncoming cars. But notice that all the cars are fairly sharp, indicating that I lingered at my pre-focused spot on the road. The grain-like appearance was added in Photoshop (Filter> Noise> Uniform> Monochrome 30%).

© Len Hellerman

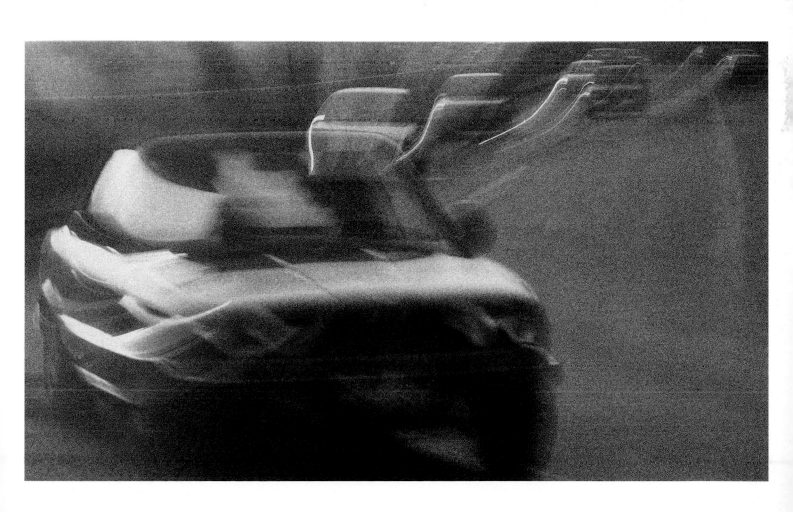

Following the Subject in a Panning Action

Unlike moving the camera while photographing a still subject, this panning approach uses a slow shutter speed to follow a moving subject. Often called the "pan blur" technique, it results in a blurred background while the subject can be recorded with varying degrees of sharpness.

Though this technique can be quite effective, it takes practice to master. A number of factors contribute to a variety of possible effects, which means it is not always a simple matter to dictate exact shutter speed settings to achieve specific results. As pointed out in the photo of the freeway cars (see page 120), one factor is the distance a subject travels in the frame during the exposure. Also, a subject moving in a parallel direction relative to the camera will appear more blurred than one moving directly at the camera. Again, the reason is the greater distance it covers across the frame versus moving toward the camera during the exposure. And of course, subjects themselves will vary in the speed they are traveling. With these caveats in mind, let's look at some applications of the pan blur technique.

Just prior to the start of a hockey playoff game, a student streaked across the ice waving the school flag tied to a hockey stick (above). I wanted him in fairly sharp focus

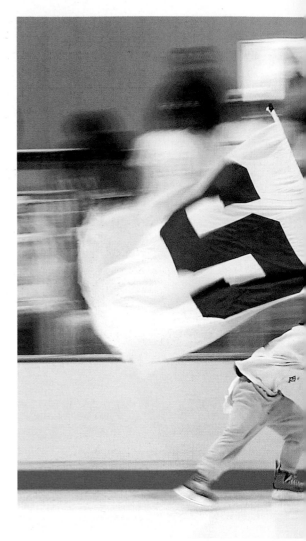

with a substantially blurred background, so I opted for a shallow depth of field (f/2.8) to help soften the background. I knew a shutter speed of 1/30 second would then add streaks to the softened background since he was moving fast. I had only one chance to get the shot, leaving plenty of room for the forward flow of movement. I fired six frames as he moved across the ice, but only the first frame caught him in remarkably sharp focus.

The old photojournalism adage of "f/8 and be there" urges photographers to always be ready, and that was the case in the photo at right, a grab shot of a dog sitting up in the rear seat of a convertible. I was ready for some street photography with my camera set to f/8 in Aperture Priority mode, which was giving me an average shutter speed of about 1/125 second. Suddenly I saw the car and dog coming with no time to look at the camera and lower the shutter speed. So, as I brought the camera up to my eye, I spun

the aperture dial to set a smaller opening in order to slow the shutter speed. I had time for just this pan blur shot. The setting turned out to be f/16 at 1/25 second. Later, I opted for a tighter crop of the dog rather than the forward direction of the car because it was really all about his human-like pose in the back seat.

The usual movement of a pan action is along a horizontal plane with the camera almost perpendicular to the moving subject, but not always. I was at an angle to the two bike riders and panned them as they came my way, setting the shutter speed to 1/15 second (right). And catching the subject at an angle was also the case in Donnette Largay's dramatic shot of a wheelchair racer (opposite page). She describes the scene with the camera at 1/15 second as follows: "I am panning on continuous drive. I focused on him in the distance, feet planted, and followed the subject from left to right for 180 degrees. This was the best of a sequence of about 20 shots."

The visual impact that results from the interplay between shutter speed and aperture, as well as the effect that interplay can have on the illusion of speed, can be seen in another of Largay's photos (right). The impression is one of pure velocity captured at 1/15 second, and quite reminiscent of Eadweard Muybridge's motion studies (see page 28). Notice how the shallow depth of field makes the rider appear to pop out from the background.

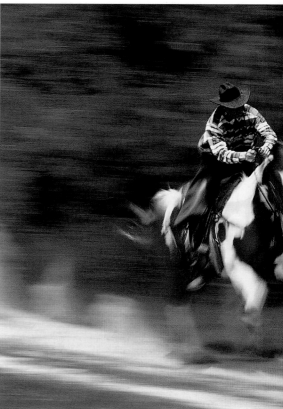

© Donnette Largay

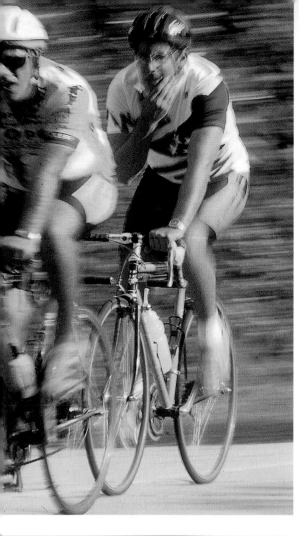

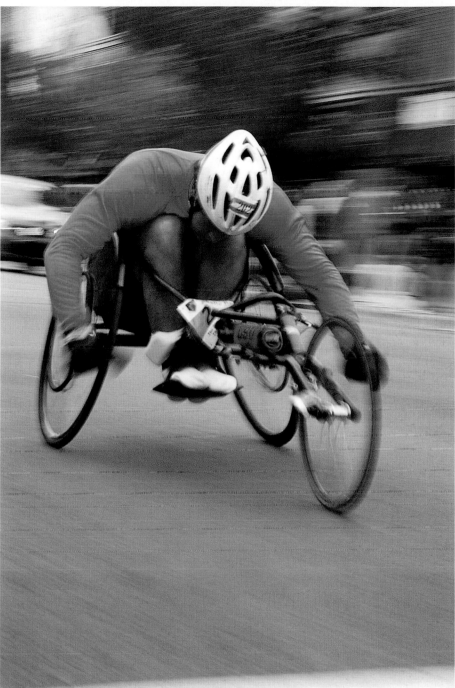

© Donnette Largay

(a) (b)

Using the Panoramic Crop

Any image, including a motion photograph, can be transformed to show a panoramic aspect ratio; simply crop it so that one side is at least twice the length of the other. The key is to make sure that the most interesting part of the captured scene is occurring within the middle third or so of the frame. Technically, this is not a panoramic image but rather the use of the panoramic aspect ratio. Also, the crop may or may not take in a wide panoramic view as opposed to simply a tighter composition of a normal or telephoto focal length.

Example (a), taken from a moving car at sunset, is an example of this narrowing of the frame. The picture is all about the ribbons of roadway and the cars moving in both directions. Originally captured on a D-SLR, the image was cropped down so that only the key subject matter was included, excluding a weak sky area. The 1/60 second shutter speed was fast enough to render cars moving in the same direction as the camera sharply while slightly blurring the oncoming traffic, adding to the sense of movement. A 180mm focal length compressed the view of the traffic in the scene.

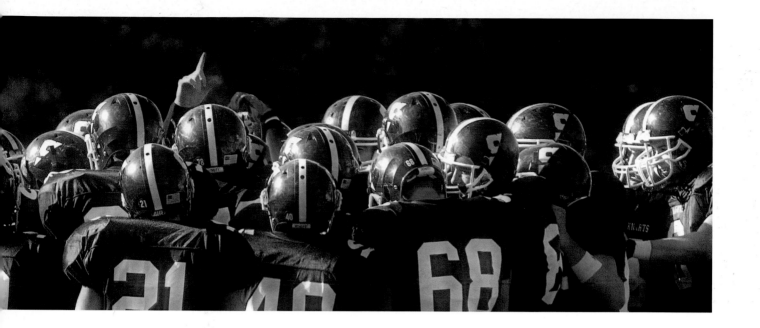

The same efforts to isolate key components and use the focal length for compression effects were employed in example (b), but the effects were even more pronounced as a result of the extreme crop of a D-SLR image taken with a 400mm lens. In example (c), I used an extreme wide-angle 18mm lens held close to the passing runners from a low perspective then applied a panoramic crop. The curvature is the result of the extreme wide-angle lens used close to the subjects, yet it looks like it may have been taken with a swing lens panoramic camera. A moderately fast 1/125 second shutter speed renders the subjects relatively sharp but still with just the slightest blurring to give the illusion of movement. The image was processed using Auto FX software; I selected an "Antique Photo" treatment. Compare that with another group of runners in example (d), captured from a distance with a

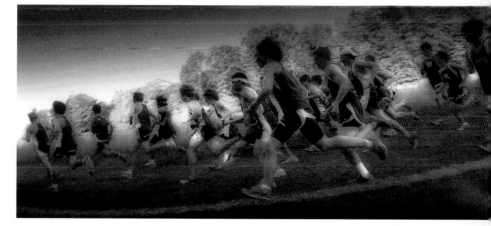

(c)

(d)

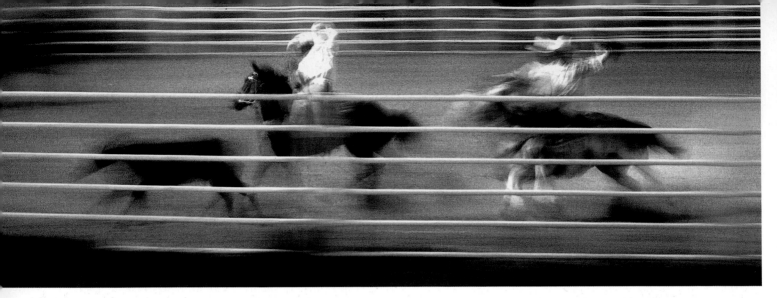

(e)

200mm lens and a pan blur movement at 1/20 second shutter speed. For the rodeo riders in example (e), I used an even slower 1/4 second shutter speed. I applied a panoramic crop to both images.

Panoramic cropping also opens up a number of different possible framing presentations, such as the use of several pictures showing the parts of a sequence all within a sectioned panoramic composition. Each photo is separate, but part of a complete sequence. In a typical action photograph, the photographer will shoot a series of pictures that actually capture a whole event, such as the scoring of a goal. The end result, however, is usually just one picture. The long narrow continuum of the panoramic aspect ratio, on the other hand, allows several of these pictures to be placed within the elongated frame to show the beginning, middle and the end of a sequence, as in example (f).

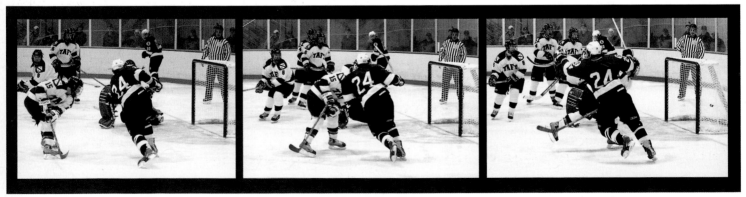

(f)

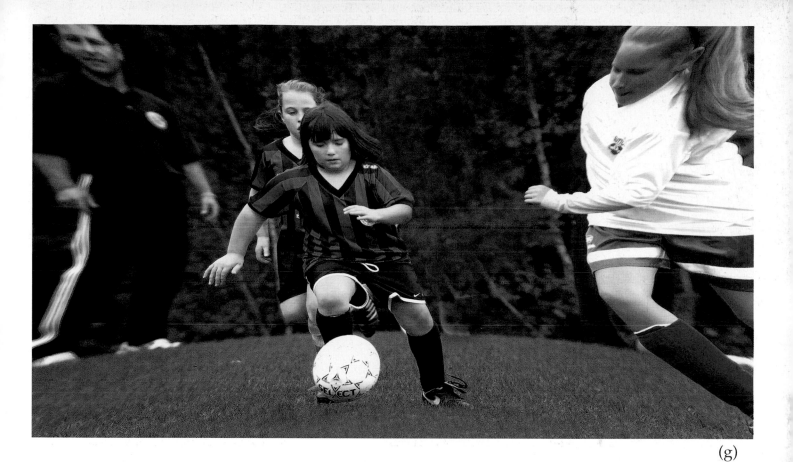

(g)

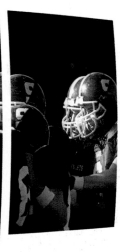

(h)

Still another variation is to photograph one subject at different magnifications. In example (g), I employed this technique by first cropping down an action shot of a youth soccer game. Then, using the effect of barrel distortion in the Grasshopper Image Align software program, I distorted and enlarged the size of the player at the corner and the person in the background. In example (h), the football shot in example (b) was cut up into a sectioned panorama and the different windows enlarged toward the center using the Grasshopper Image Align software Pincushion Correction/Distortion tool.

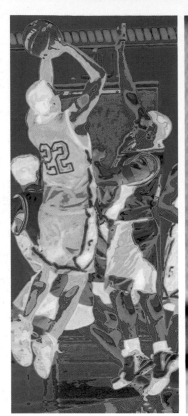

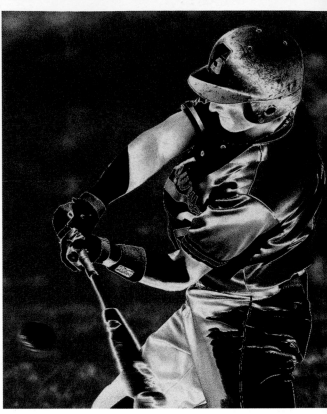

6 Photographing Sports

The most popular subjects for motion photography are sports competitions. Such opportunities are available nearly every day of the year, either on outdoor playing fields or indoors on gym courts or arenas. Towns and cities usually have a range of youth programs as well as adult leagues, to say nothing of the extensive interscholastic and intramural competitions at local public schools. Indeed, most photographers have undoubtedly been asked to take pictures at such events for family and friends. These local venues have one major advantage over professional competitions: They usually don't require special pass privileges or press credentials as occurs with pro sports. Even college sports will have some restrictions, especially in the case of schools with big-time programs.

Since you are more likely to deal with the wide range of local sports, the emphasis in this chapter will be on techniques that work well with these amateur competitions. One chapter cannot fully detail all aspects of this specialized field. What follows, rather, is a general guide for covering athletic events using the compositional approaches and camera techniques examined in previous chapters, as applied to several popular outdoor and indoor team sports.

Sports Action

All levels of sports photography share certain important requirements. First, you should have a clear idea of your purpose. Is it to follow the moves of an individual player or to record a cross section of team efforts, or is it to just try for some good pictures of either team? Going to a game and just winging it without a general idea of what you hope to capture is a low percentage approach. Your ratio of successful shots will likely be improved by having some sort of plan in mind.

Second, while each sport offers a unique set of possibilities for great shots, there are also challenges that must be considered. For example, baseball games have a predictable pattern of action between the pitcher, catcher, and batter that is relatively easy to folow and record. Once the ball is hit though, the photographer has to be quick enough, and in the right position, to capture the action that can suddenly spread out on the field. Meanwhile, basketball players often display acrobatic moves that can make for very dynamic pictures. However, many local gyms do not have enough light to use action-stopping shutter speeds, and in addition, may well have a rule of "no flash photography." So, be cognizant of these possible limitations, as they will affect what you can and cannot do.

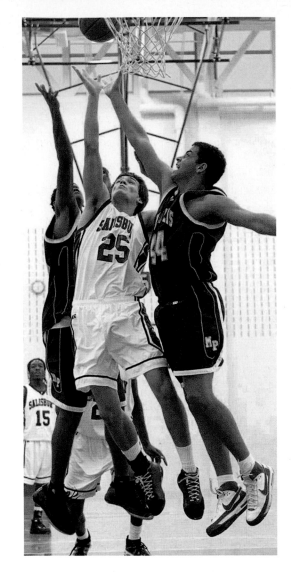

Third, you also need to be realistic about the capabilities of your equipment in relation to your goals. That is, how well do your lenses and camera match the demands of the pictures you are after? Do you have an adequate burst rate, is the camera's image quality good at high ISO settings, can you set a focal length long enough to sharply capture action across the field? That said, even the most limited equipment can record good pictures provided the photographer sets realistic goals and makes the best use of what she or he has.

Outdoor Field Sports

Finally, there is always the need to antici-pate what is going to happen, coupled with a sense of timing and a good deal of patience. Having a good knowledge of the sport helps with anticipation and timing, as you can better predict where the next action is going to occur. I knew in the photo on the opposite page (left) that there was likely to be a rebound when a long range shot was put up moments previously.

As discussed in Chapter 4, timing evolves from the detection of direction and patterns of movement. Patience, on the other hand, is a quality that each photographer has to develop through personal discipline. In the end, there is no other way to develop a skill for photographing sports other than going out and taking lots of pictures and then evaluating the results during the edit-ing process. With all this in mind, let's look at some of the ways to photograph a few of the outdoor and indoor sports.

In general, outdoor field sports such as foot-ball, lacrosse, baseball, and soccer have the advantage of good levels of natural light for fast shutter speeds, especially when played during daytime. The usual rule is to take a spot where the light is behind or to the side of your position so that the players are not in full shadow. Bright, overcast days, or those with a thin layer of clouds in front of the sun are excellent for even coverage. This type of light does not cast strong shadows so you can be more flexible about where you stand. For backlit subjects, the usual rule is to open up one to two stops using the camera's exposure compensation func-tion. This increases the exposure while the camera is set in either Aperture priority or Shutter priority exposure modes. Well-lit night games often have high-contrast light-ing that is slightly more even than the single source of the sun on a clear day.

One big disadvantage of most field sports is that they take place on a very large playing field. So the name of the game is location, location, and location! But it also means you cannot possibly expect to cover the whole game from one position. Fortunately, local sporting events generally don't have strict rules about where you can stand. Still, it might be a good idea to check with the coach or athletic director to make sure it is

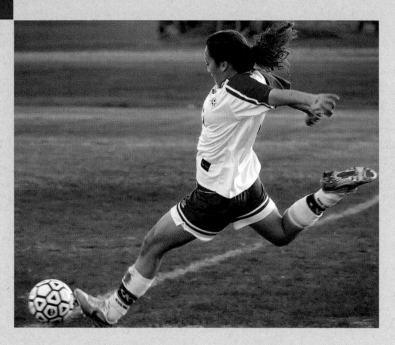

Try to avoid shooting everything everywhere on the field. Unless you are close enough, the players will occupy only a small portion of the picture, which means you would have to substantially enlarge that area during post-processing in the computer to adequately see them, and that can often result in poor general quality. Try filling your viewfinder with the players so that they account for at least 60–75% of the picture area. You can then crop so that the subject becomes even more of the total picture, as seen in most of the examples in this chapter. The megapixel (MP) count found on most sensors in today's DSLRs should be more than enough to make a high-quality 8 x 10-inch print (20 x 25 cm), even after cropping. Filling the viewfinder is an important technique because that is how you capture such telling details as facial expressions and the physical contact between players. Moving with the flow of the action, rather than standing in the same spot for the whole game, is really the key to staying at a reasonably close distance to the action. Local sports give you the ability to move around, and you should use it to your advantage.

okay to work from the sidelines. In general, they will not want you anywhere near the players' benches, so that means shooting from the corners and ends of the field, both of which offer plenty of opportunities. For example, in sports where there is a specific goal area, such as soccer, lacrosse, and field hockey, some of the best compositions will come when you are about 20 yards from the front of the goal and shooting at a diagonal to the goal. This increases the chances of having the attacking player, defenders, and the goalie in the picture.

Finally, there is the question of photographic equipment. As you will see in the examples throughout this chapter, the 200–400mm focal length range is very useful for large-field sports. If you are using a digital SLR with a smaller than full-frame sensor (many have a focal-length correction factor of 1.5x or 1.6x), you will shoot with the 35mm equivalent of a 300–600mm focal length. More moderate focal lengths of 100–200mm will be adequate if you are able to work in closer proximity to the players. A zoom lens, as opposed to a fixed focal-length lens, has the advantage of allowing you to adjust to different degrees of framing as the action unfolds. Most sports shooters try to isolate the players from distracting backgrounds by using shallow depth of field settings, such as f/2.8. But, the fastest telephoto zooms with such wide apertures are very expensive. On the other hand, these lenses are highly corrected and will deliver superb quality. A typical professional sports kit might include a fast telephoto zoom in the range of 80–200mm f/2.8, a 300mm f/2.8, and longer 400mm, 500mm, or 600mm single focal length telephotos with maximum apertures of f/4 to f/5.6.

Fortunately, you don't need to spend pro-type money for lenses and cameras. Manufacturers are now producing good quality telephoto zooms at reasonable prices with a range up to 400mm and maximum apertures of f/5.6. These work very well for local sports. Many of the illustrations in this chapter were taken with an 80–400mm f/4.5–f/5.6 zoom. You might also want to consider shooting with a monopod when using longer and heavier lenses, not only for added stability, but to prevent fatigue in your shoulders and arms from the weight.

Your particular camera's speed of taking and recording images will control how fast you can shoot. Slower capture rates of 1.5 to 3 fps will limit you compared to faster continuous rates, but you can still succeed in producing good pictures provided you position yourself appropriately and recognize opportunities as they arise. Cameras with rates such as 5 to 8 fps will increase chances of success, but remember that other factors also influence the number of shots you can take in a given time frame, including the camera's processing buffer capacity, memory card speed, and type of file format used for recording.

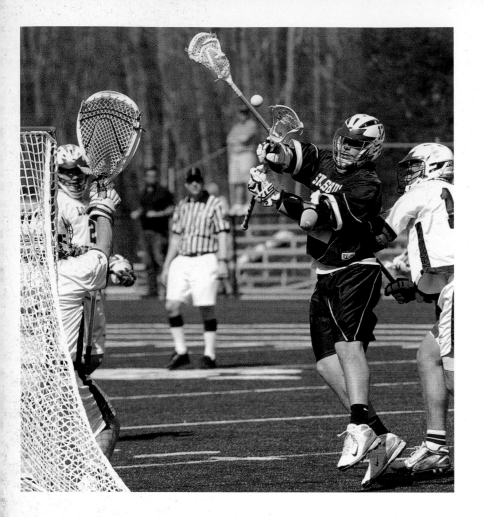

the ball with their feet. The dynamic exception is when players leap into the air to head the ball, or when a goalie jumps to block a shot.

As players in both sports work the ball in the open field, their movements have patterns that can be followed in the viewfinder. Keep in mind, however, that they are moving fast, and that is the challenge. The standard shot in the open field comes when you try to isolate one player moving the ball or two or more competing for the ball. Patience pays off when you wait for the players to come close enough to occupy 60% or more of the scene in the viewfinder. Many times it will seem that you are "out of the game" because the action is taking place across the other side of the field, so you will have to move around a lot and be patient. In soccer, the easiest shots are the overhead throw-in, corner kicks, goal kicks, and penalty kicks because the action stops for a moment and the players get set before starting up play. The more difficult shots—but the ones with a greater potential for a dynamic picture—occur around the goal and when two or more players are attempting to head the ball.

So let's look at some methods you can use to increase the chances of getting a good shot. Remember the three guidelines: (1) know what you are after and where to stand to get it; (2) be aware of any limitations (be they lighting, location, or equipment); and (3) look for patterns and directions of play to help anticipate when to press the shutter.

Soccer and lacrosse are games of constant movement across the entire playing field. The most dynamic pictures in such sports typically come from one of two situations: (1) The open field struggle between two or more players vying for control of the ball and, (2) the shot on goal (above). Overall, soccer is about capturing players working

With lacrosse, the set-up shots are the face-off in the middle of the field, as well as throw-ins and when the offense passes the ball around the goal as the attacking team works for a shot. The shot on goal is the hardest photo to capture in lacrosse; partly because there are usually other players in the area of the goal making it difficult to get

a clear view, and also because the action of shooting on goal occurs quickly. For both sports, catching the action from the sideline is the usual practice, but if you have a long telephoto, shooting from the opposite end of the field aiming at the goal can be very dramatic as seen below.

Soccer

The purpose of the two images on this page is to isolate a single player competing with opposing players. Patience was key as I selected a subject and waited for that player to get the ball and be near enough to compose without a distracting background. Taking a position in the general area of where the subject plays on offense or defense is a good start. In the shot of the high school boy, I used an action freezing shutter speed of 1/1000 second with shal-

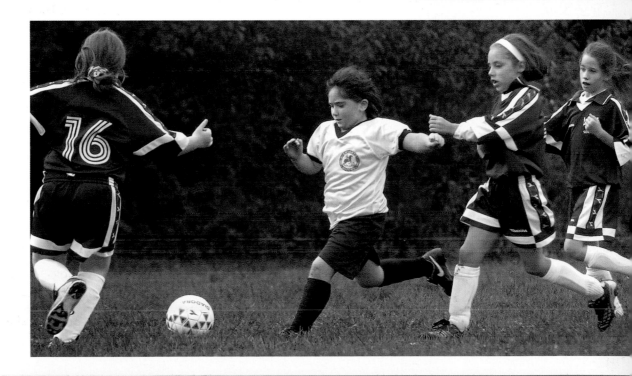

low depth of field (f/4.0) on a zoom lens set at 200mm. In the computer, I cropped out sections of the picture to reinforce the isolation of the subject from other nearby players. The capture of the girls was taken from a kneeling position (as opposed to standing) for an eye level perspective. This lower perspective often offsets the small size of younger players, making them seem larger and more imposing. Taken at 1/350 second with an aperture of f/6.7, this picture was cropped to preserve the path of motion of the ball and players at the left of the frame.

As mentioned, it is easiest to prepare for soccer throw-ins and the various types of free kicks. Usually having the ball in the picture is a good idea, as shown in the upper photo to the left, where the shutter speed was 1/1000 second. In the frame below that, also taken at 1/1000 second, I was able to catch the goalie looking up and in full extension after the kick.

Penalty kicks are dramatic moments in which defending players stand in a line waiting for the kick. Consequently, there is tension that you can catch in the body language and expressions of the defenders, as shown in the top picture on the opposite page (1/1000 second). Always look at your photos in the computer to see how you can improve shots by cropping to eliminate extraneous elements that may appear to the side or background of the main action. This photo is notable for its uncluttered background.

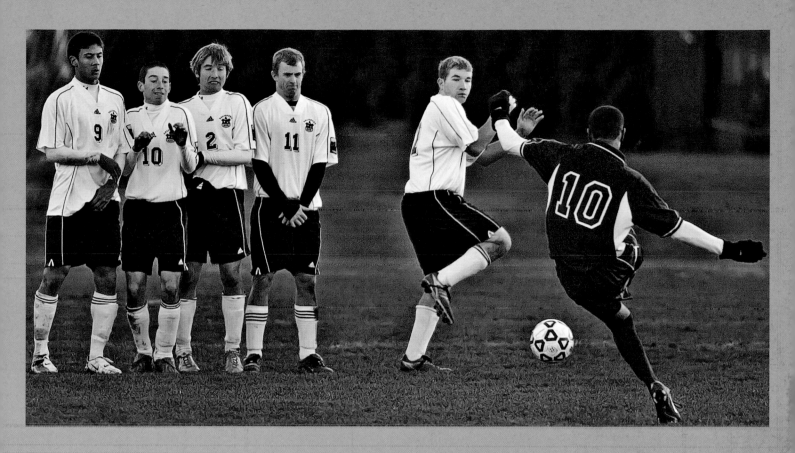

Believe it or not, photos where players head the ball (right) are relatively easy to photograph once you learn to estimate where the flight of a ball is going to land. (The trick is to be close enough to fill the viewfinder without anyone blocking the photo.) When a ball is hit high, I estimate where it will fall and look there for the players getting into position. I then focus on them, preparing to move the camera upward as they jump. The best shots are when you can catch the ball in the picture with lots of strained expressions on the players' faces. These types of shots usually require a shutter speed of 1/1000 second or faster.

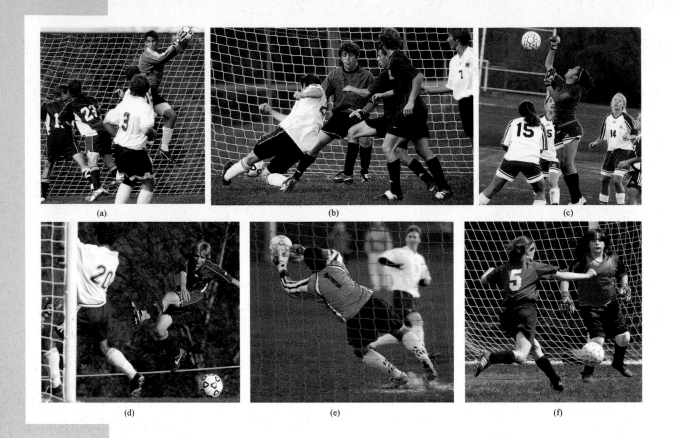

(a) (b) (c)

(d) (e) (f)

A shot on goal is the most exciting moment in soccer, as seen in six panels of the illustration above. I always use a minimum shutter speed of 1/500 second—and usually as close to 1/1000 second as possible—whenever shooting this part of the field, with a shallow depth of field to isolate the players. The composition should ideally include the player making the shot, the defending goalie, and perhaps some other defenders. Some of the most dramatic compositions can come from shooting straight on from the opposite end of the field using a telephoto focal length, in the 400 to 500mm range, as in frames (a) and (b). Note how the netting serves as background.

Alternatively, standing diagonal to the mouth of the goal will also yield good compositions as in frames (c) (d) and (f). Finally, there is the option to shoot through the back of the net frame (e). But be careful, as the net may interfere with the auto focus, requiring you to switch to manual focus.

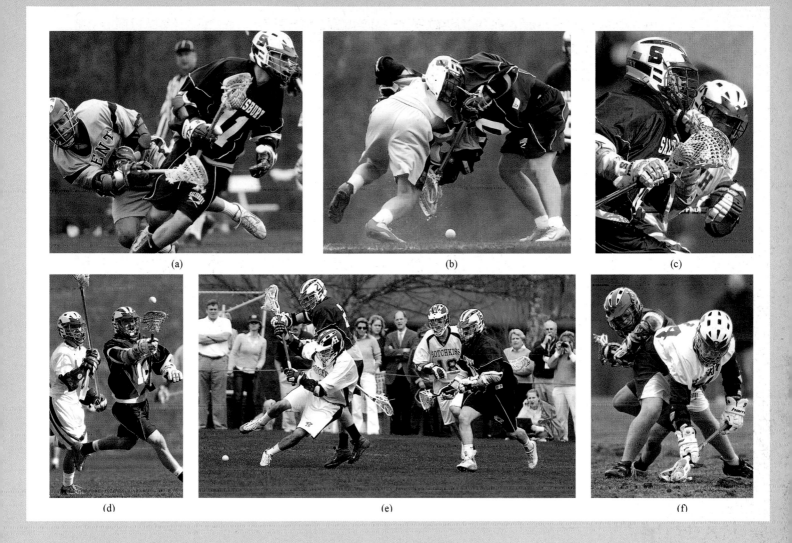

(a) (b) (c)

(d) (e) (f)

Lacrosse

The open field shot of lacrosse players vying for the ball is similar to open field soccer, with one important exception: You need to make room for the long lacrosse sticks during the action. Much of what happens on the lacrosse field consists of digging for the ball, slashing at the opponent's stick to knock the ball out, passing, and running with the ball tucked in the head (the netting at the top of the lacrosse stick). Because of the need to change the focal length to accommodate the sticks, I usually shoot lacrosse with an 80–400mm or a 200–400mm zoom at between f/4.0 and f/5.6 to isolate the players. As with soccer, a shutter speed from 1/500 to 1/1000 second is required to freeze the action. In addition to open field shots, there are also face offs, as seen above in frame (b), which was shot from a low perspective. Digging for the ball in the open field can happen anywhere when a ball is knocked out of the head to the ground, as in frame (f). Because players carry the ball to

move it up field, I have found it fairly easy to get the sorts of close-in shots seen in (a) (c) and (d). I just follow the player while filling the viewfinder to eliminate backgrounds. On the other hand, once you pull back on the zoom to take in a wider action composition, backgrounds can become more apparent and distract from the action, as in frame (e). Some photographers prefer to have spectators in the picture, but I strive to isolate whenever possible.

Lacrosse shots on goal are really tricky to get, especially when trying to include the net and the defenders as well as the ball. I have had success shooting from the opposite end of the field when other players in midfield don't get in the way (illustrated below, left frame). As with a similar shot during a soccer match, this takes a long focal length of 400 to 500mm. The easiest type of shot on goal to photograph is when an attacker approaches

with the ball still in the head of his stick, but that is not as dynamic as a player who is actually in the act of shooting (below, right—notice the ball on the ground).

Football

Unlike soccer, the action in football is not continuous, but divided into plays beginning from the line of scrimmage. Thus, you have time between plays to reposition yourself and decide where on the field you want to catch the action, whether behind the offensive line or downfield behind the defensive line. Unfortunately, some of the best positions are on the sidelines where players not in the game often stand as they follow the line of scrimmage up and down the field. So unless you have permission to stand with the players, it becomes a matter of shooting the angles.

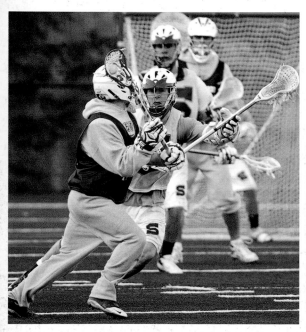
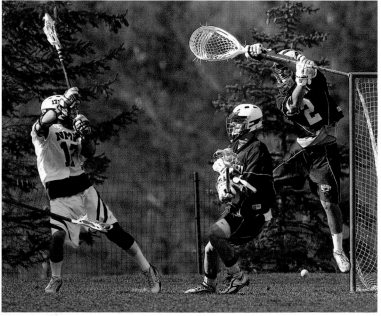

Once again, it is helpful to think ahead about what you want to capture. For example, do you want to show the offensive action of the quarterback, the moves of a runner, a catch made by the receiver, or the collisions of the linemen as they battle in the trenches? On the defensive side, there is the tackle, the interception, and the blocked pass. The following examples will give you some idea of the shots you can get from either side of the line of scrimmage.

As demonstrated in the photos to the right, positioning yourself approximately 10 to 20 yards back from the scrimmage line allows you to catch the quarterback in action, whether handing the ball off (top), passing (and maybe even having the pass batted down by a defender), or running. These are "bread and butter" shots that require a zoom in the 100–300mm range. Though not always possible, waiting for the quarterback to turn in your direction often pays photographic dividends.

Another type of shot from behind the offensive line that can be dynamic and dramatic is one that captures a running back trying to break free on a long gainer through a hole created by his linemen (bottom). Shutter speeds of around 1/500 second are enough to freeze the type of action seen in these types of plays.

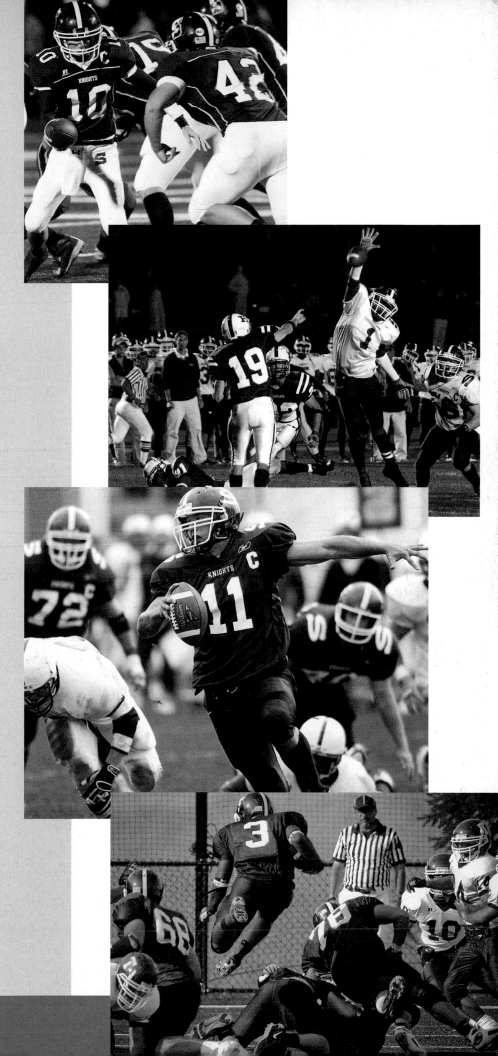

Behind the Defensive Line

Shooting anywhere from 10 yards behind the defensive line to as far back as the end zone offers the ability get a good angle on tackles by the defense. The action from this vantage takes several predictable routes, among them a long run around end (light cyan tone, top) or directly off tackle (cyan-otype, middle) into a gang of defenders. This is also a good position to catch the blocking in the interior line (Van Dyck tone, bottom). All three of these images were converted to monochrome and given the traditional black and white tones in Tiffen's Dfx software.

The key to catching these sorts of plays is to watch the quarterback. I try to anticipate the direction of the play by analyzing the formation when the offense comes to the line, watching for the pass receivers to spread wide from the line. I then set the camera on the quarterback. A running play will develop very quickly, so you should be able to spot the handoff and runner. Then it becomes a matter of when to click the shutter as the play develops. If the point is to record the defense making a tackle, I follow the runner in the viewfinder and press the shutter button as soon as the defensive players start to close in.

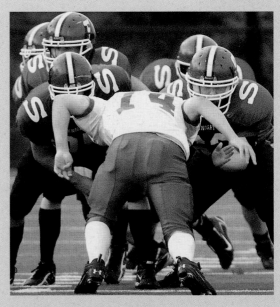

Standing behind the defensive line is also a good position from which to photograph a pass reception (upper right) as well as the moves of the pass defense to break up the catch (middle right). A pass play will take a few seconds longer than a running play to develop as the quarterback prepares to throw, and then the ball will be in the air for an additional two or three seconds. Thus, if you are quick enough to anticipate a pass play by watching the quarterback, the key then becomes estimating where the ball will come down to the receiver (which assumes you can see the receiver from your position in the first place). You will have to be alert for the reception photo because it can literally take place anywhere on the field.

Baseball

Baseball is the most regimented of all field sports since each player takes a specific position on the field and usually only plays in that area. The most dramatic shots are most often plays in the infield, as well as the interplay between pitcher and batter. Occasionally, you can get a great catch in the outfield. Slides into second, third, and home can be dramatic, as are fielding plays made by infielders in general. Your best overall position is one that will give you a clear view of the four bases and the pitcher.

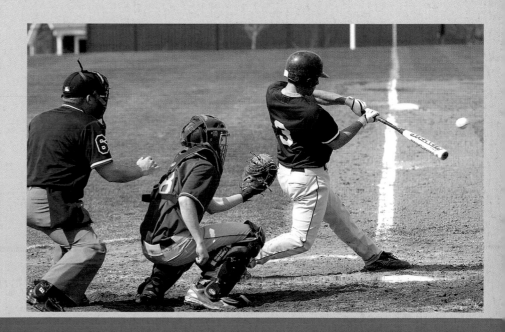

Two good spots are half way between third and home or first and home, depending on light direction. A zoom lens in the moderate range, such as a 70–300mm or 80–200mm, will cover the whole infield. Since the players basically stay in certain areas and the base runners have to follow a set path, you can set up for a shot according to who is on base. The direction of the base runners is a given, so the key is to be ready when the ball is hit. For example, with a man on first, there is a good chance a slide into second will occur with any ground ball to the infield. Another predictable shot is catching the pitcher attempting to throw to first base to pick off a runner (see page 57).

The individual pitching styles can be represented by capturing any number of different segments as seen in the "Seventeen Pitches" poster illustrated on the opposite page. Because the patterns in an individual's motions are predictable, you can capture any segment you want with a little practice. Shutter speeds of at least 1/500 second are recommended for sharp images.

Also predictable is the pattern of a batter's swing, as shown in the example at the bottom of the previous page. That photo catches the swing just as the bat is about to make contact—you can see the ball in the photo about to be hit. A different kind of shot is to use a long telephoto, such as a 500mm, and photograph the batter from behind the center field fence (below). The key here is to arrange the composition so that the pitcher is also in the frame, along with the ball.

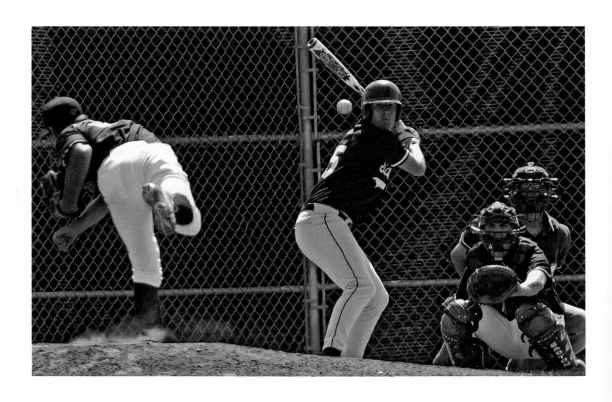

SEVENTEEN PITCHES

1

2

3

4

5

6

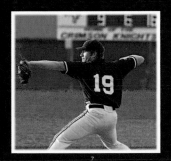

7

8

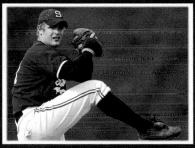

9

10

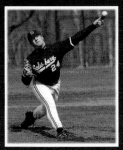

11

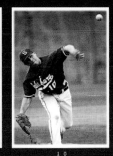

12

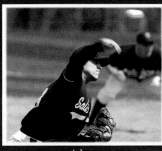

13

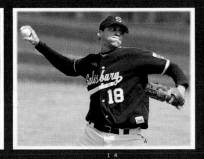

14

15

16

17

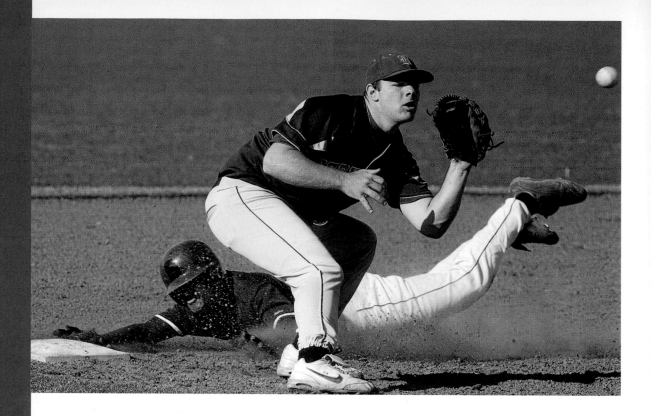

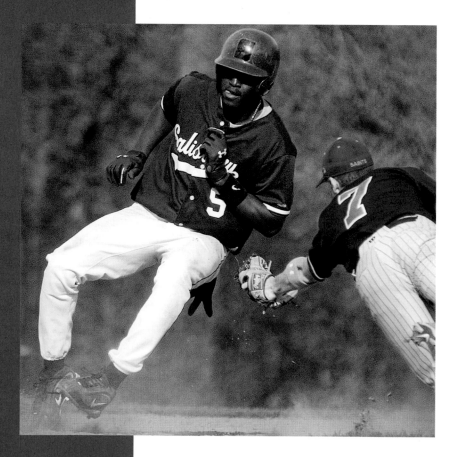

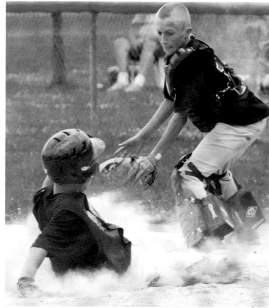

Plays in the infield are the mainstay of baseball photography. Again, as the examples on this page illustrate, I use a fast shutter speed to freeze the action and an aperture wide enough to isolate the subjects from the background.

Indoor Sports

Basketball

All indoor sports present challenges to the action photographer because of the lower intensity (which affects the ability to set fast shutter speeds) and variable quality of available light, as well as its typically uneven coverage. In order to stop the action of fast-moving basketball players, shutter speeds of at least 1/250 second are preferred. I like to use the widest aperture possible (f2.8 or wider), depending on the focal length of the lens. One of my most useful lenses is a 50mm f1/.4 prime that is very effective when I am positioned close to the basket. Otherwise, I use a 24–70mm f/2.8 zoom as my main lens when farther from the basket and along the sidelines. Even with these fast apertures, I often find myself setting ISO at 800 or 1600 to help deal with the low light levels in gymnasiums. That invites the possibility of increased noise and a need for one of the noise filtering programs that are now widely available.

There may also be an issue with the quality of light coming from the mixed sources typical of local gyms. It is not unusual to find lamps of different types (incandescent and fluorescent) inside a school gym, and they therefore may well be the sources of various Kelvin temperatures, producing a mixture of different color output. The resulting images may require color correction later in the computer. In general, using the Auto White Balance setting is the best strategy.

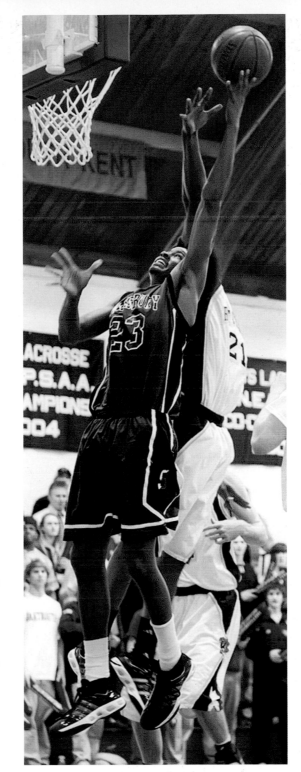

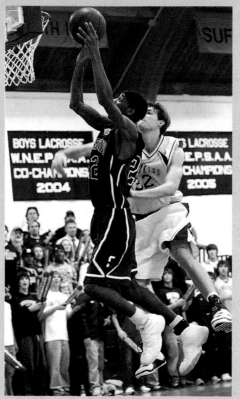

Finally, it is not unusual for the lighting to fall off significantly at the edges of the playing surface at an indoor venue. Using the Aperture priority setting should help offset this deficiency.

The best positions for photographing basketball is at either corner where the end lines and side lines intersect, or just behind the baseline on either side of the basket. (Some referees will ask you to move if you try to position yourself directly under the basket or too close to the baseline.) The images at left are typical of compositions you can expect from these locations. These were taken from along the baseline—the vertical photo is actually one of the easiest types to record because it becomes obvious that peak action is about to occur when players rise into the air to grab a rebound or drive for a shot. It is a relatively simple matter to time the action.

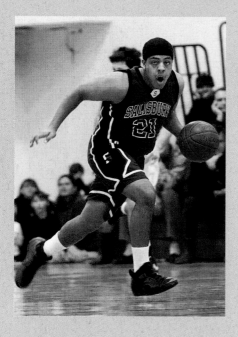

Another popular shot is to isolate one player making a drive, as shown in the photo on the bottom left. The idea here is to get as clean a composition as possible and capture the particular player's style. I prefer to have the ball in the hand of the player since this shows the greatest level of control during the drive. Having both feet off the ground adds to the illusion of speed.

Hockey

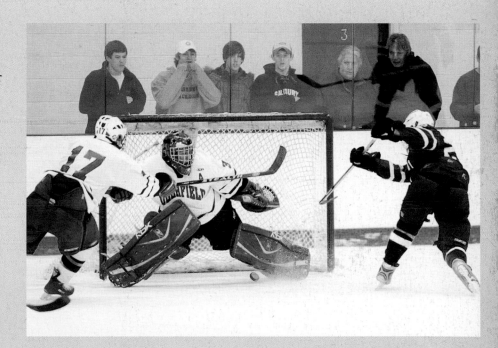

Hockey is a difficult sport to photograph for a number of reasons. First, many rinks have netting all around to protect the spectators from wayward pucks. Second, if you are at rink level and shooting through the glass, it is often marred and marked from play (and usually tinted green—ugh!). Then there is the fact that the players are moving very, very fast on their skates.

One of the bread and butter shots in hockey is to isolate a player moving with the puck. I prefer to get this composition with the subject fending off an opposing player, as in the top left example. I also look for the "stretch," as I call it, when a player will reach out and stretch with their stick to keep control of a puck (top right).

A shot on goal or the goalie making a save are among the most popular images in hockey. Typically, things get really crowded in front of the goal-mouth and it is often difficult to get a clear view of the play. What I generally look for is that moment when the shot is taken and the puck is in view (above), or when the puck is free and dangerously close to the mouth of the goal causing frantic moves on the part of the players.

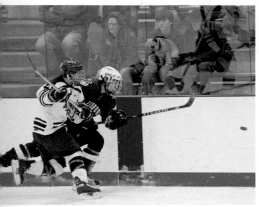

One of the interesting things about hockey photography is the occasional inclusion of the crowd, which is very close to the action and separated by only a pane of glass. Sometimes, spectators' faces are as interesting as the play on the rink, as shown in the examples at left. Notice the dog watching the play (top left frame) and the expressions on the spectators' faces in reaction to the players slamming into the boards (top right).

Speaking of spectators, don't forget to be ready for what happens immediately after a score. In particular, some games have relatively few scores, such as hockey and soccer. A goal often becomes a big event in those sports, so you can generally get a really good crowd reaction (left). Then there is the unbridled joy (and chaos) that can come with a win at the end of a close game, as seen in the photo on the opposite page; notice the lost sneaker on the floor.

I have only touched on team sports, merely pointing to ways that the principles of motion photography can be applied to capturing the beautiful movements of people in organized competitions. Certainly the same principles apply to individual sports such as tennis, wrestling, squash, swimming, cross country, track, etc., and to other team sports

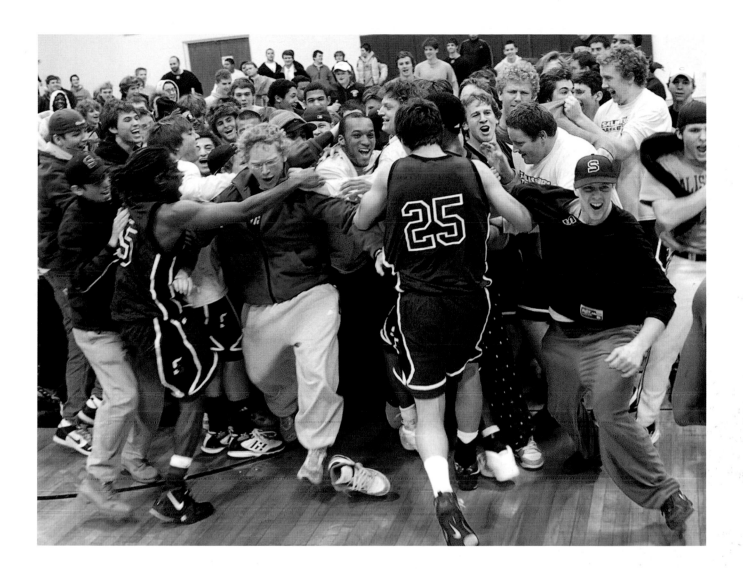

not covered here. To be sure, the fact that there are many more players performing on the field in team sports usually means there are more chances to get a good picture. But in the end, it all comes down to defining your purpose, being aware of the challenges, dealing with the limitations, and developing a sense of the direction and patterns of the players.

INDEX

I

J

K

L

M

N